Portsmouth Women

Portsmouth Women

MADAMS & MATRIARCHS WHO SHAPED NEW HAMPSHIRE'S PORT CITY

Edited by Laura Pope

THE
History
PRESS

Published by The History Press
Charleston, SC 29403
www.historypress.net

Front cover, clockwise from top left: Mayor Mary Carey Dondero emerges from a submarine at the Portsmouth Naval Shipyard. *Courtesy Mary Carey Foley*; The Just We Four Club from the Italian North End featuring (back row) Connie Canino, Connie Cochario, (front row) Ann Fiandaca and Edie DeStefano. *Courtesy Pamela Fiandaca Given*; Bordello madam Alta Roberts. *Courtesy Kimberly Crisp*; *The Warner House*, watercolor by Sarah Haven Foster. *Portsmouth Public Library, Portsmouth, NH.*
Back cover: Dondero's Fruit Stand on Congress Street. *Patch Collection, Strawbery Banke museum, Portsmouth, NH*; Self-portrait of Susan Ricker Knox. *Peter A. Juley & Son Collection, National Museum of American Art, Smithsonian Institution.*

First published 2013

Manufactured in the United States

ISBN 978.1.62619.100.6

Library of Congress CIP data applied for.

Notice: The information in this book is true and complete to the best of our knowledge. It is offered without guarantee on the part of the author or The History Press. The author and The History Press disclaim all liability in connection with the use of this book.

To the intrepid Ella Wilson Morrison.
To the memories of Elizabeth P. Nowers and Jane D. Kaufmann,
who contributed their expertise to this book.
And to all Portsmouth women, ordinary and extraordinary,
who came before us.

Contents

Acknowledgements

Heartfelt thanks to my foremost supporter, John P. Schnitzler, for his unwavering encouragement and sage advice; to Jan McCracken for her timely suggestion to try another round of publisher inquiries; and to loyal friend and artist Jane Kaufmann, whose imagination and spirit make all creative endeavors adventurous.

My thanks and gratitude to all the contributing writers, whose curiosity, participation and patience made this book possible. Their willingness to push forward, to introduce new histories about Portsmouth women and to wait several years before a publisher came forward is a testament to the storyteller gene within all of us. It's been a privilege working with them.

My appreciation goes to the many who helped me gather photos for this book: Nicole L. Cloutier at Special Collections, Portsmouth Public Library; historians J. Dennis Robinson and Maryellen Burke; Tom Hardiman, Keeper at the Portsmouth Athenaeum; Elizabeth Farish at Strawbery Banke museum; Nancy M. Carmer, Richard Hopley and John Bohenko at Portsmouth City Hall; Susan and Chip Kaufmann; Joseph Fiandaca and Pamela Fiandaca Given; Kimberly Crisp; Dr. Richard Candee and Robert S. Chase; Deborah M. Child; James Garvin; and the New Hampshire State Archives.

Lastly, my sincere thanks to the gimlet-eyed Brenda Gaudet, who ensures all writers' words read well.

Introduction

The curiosity that presages action—in this case, the seed that spurred putting together this anthology of women's history—began in the mid-1980s, following my time as an archaeologist at Strawbery Banke, a ten-acre maritime museum in the lively river town of Portsmouth, New Hampshire. Like other staff, I found myself immersed in the histories of founding families, sea captains, merchants and craftsmen, but I could not stop wondering about the sisters, wives and mothers of these prominent citizens.

After gathering a list of subject women, whose quite varied lives spanned three centuries, I then paired each with a female biographer from the ranks of journalists, historians and scholars. The eight biographies in *Portsmouth Women* represent, for the most part, new histories of women well outside the mainstream.

Employing a full arsenal of research methods—from oral histories, letters and public records to genealogies, new scholarship and discovery of new materials—the biographers of *Portsmouth Women* unearthed a satisfying, if small, sample of female history in the city.

A major thoroughfare in the city summons the memory of a twice-widowed philanthropist, Bridget Cutt Daniel Graffort, who devoted her real estate to education. During her life in the seventeenth-century, fledgling city, she witnessed several skirmishes and more than one war between colonists and native peoples and rose to wealth as the widow of distinguished men.

In her biography, we get a glimpse of upper-class life, orderly Puritan hierarchy and how a father's love of education passed to his daughter and,

ultimately, to Portsmouth. We get a snapshot of a prominent woman during a time when women's roles might have been appreciated but never saved for future generations to explore.

Another widow, Allice Frost Shannon Hight is barely remembered as a tavern keeper before the American Revolution, though a few remaining tax records reveal a tenacious woman who outlived two husbands and raised ten children, all while helping to run a prosperous tavern and ferry service. She is the quintessential model of super motherhood. Elizabeth Nowers recounts Hight's story here. Based on information culled from surviving wills, court documents, newspaper advertisements and tax records, it is a sobering glimpse of eighteenth-century business practices involving real estate and legal issues.

Female artists left their mark as well.

Sarah Haven Foster dedicated her words and art to preserving a nostalgic view of Portsmouth in her *Guidebook* and, thus, added tremendously to the city's future tourism industry. Maryellen Burke authors a detailed peek into this talented artist's life.

Quite famous in her day, Portsmouth painter Susan Ricker Knox virtually evaporated from the historic record after her death. Historian Jane D. Kaufmann revives Knox's considerable contributions to the art world here as well as her influence over immigration legislation.

Ellen and Brownie Gerrish—the wife and daughter of sea captain Edwin Gerrish—went to sea to face unimaginable perils and were only recorded in the historic record because of their involvement in a famous Civil War sea battle. Here, their lives on ships speak to the issue of women's roles at sea, a topic that has gained considerable academic attention in the last few years. Sailor, scholar and writer Kate Ford Laird breathes life into an existence at sea that a small number of women experienced at this time.

Mary Baker and Alta Roberts were enterprising women whose stories are often deliberately obliterated through a lack of further investigation or an unwillingness to discuss the subject of Portsmouth's once flourishing prostitution trade along the waterfront, especially since this same district now encompasses the city's finest park and the largest arts festival in the region. Kimberly Crisp, grandniece of Roberts herself, tells their stories, as well as their distinct brand of commerce, here.

Among these pioneering spirits and ordinary women may be found a couple of real charmers, including a Sicilian immigrant named Rose Rizza Fiandaca, who reigned as the unofficial matriarch and midwife of a bustling Little Italy, and a poor girl named Mary Carey Dondero from the South

End, who later became the first female mayor in Portsmouth and a beloved political figure for whom a Portsmouth elementary school is named.

Though this book is just a first step in the direction of relating compelling stories about Portsmouth women, it will perhaps instigate more scholarly research into the surprisingly varied and interesting lives of women in Portsmouth and other communities already rife with the histories of male accomplishment. In additional pursuits of female history, more information about notable women from witness accounts, oral histories, diaries, museum catalogues and newspaper clippings may be identified and organized, ultimately finding its rightful place in our collective history.

Laura Pope

Bridget Cutt Daniel Graffort, 1651–1701: Portsmouth's Widow Philanthropist

BY KATHLEEN A. SHEA

I n the name of God Amen. I Bridget Graffort of Portsmouth in New Hampshire, in New England being in a Languishing Estate of Body, & Apprehending my Change drawing nigh. I Will & bequeath…"

On her deathbed in her upstairs chamber, Bridget Cutt Daniel Graffort dictated her last will and testament on the first day of April 1701, dividing her worldly possessions among her many relations. A wealthy widow with no children, she left most of her estate, valued at more than £1,300, to her nieces and nephews. She was the last of her generation, outliving her sister, her parents and two husbands after only half a century.

Uncovering the story of Bridget's life presents a challenge, for she would remain anonymous today but for a few fading documents. There is no existing record of her birth, and her gravestone sank into the ground long ago. Yet the sparse details of Bridget's existence provide an opportunity to examine the experience of women in seventeenth-century Portsmouth.

Although her story was shaped by her wealth and her family's status in Portsmouth society, Bridget shared the common experience of women living in a colonial English community on the edge of the New England frontier. Like most women of her day, she was not famous or known beyond the circle of her family and friends. The will she wrote on her deathbed and a probate inventory taken after she died provide a window to her world, yet much of her life experience will remain hidden forever in the private realm of women's history.

In seventeenth-century New England, women were virtually excluded from the public arena, and because they had no voice or vote in public

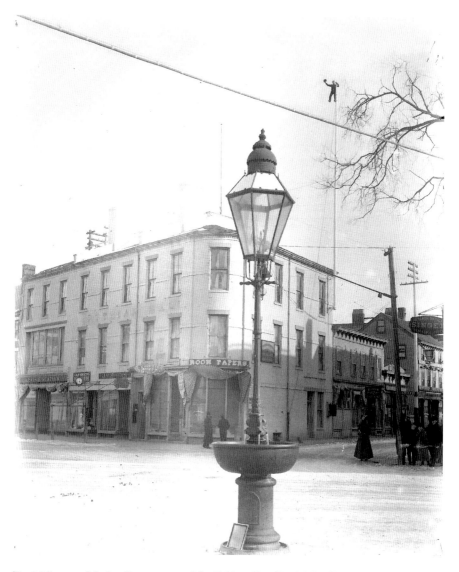

Daniel Street at Market Square, named for Bridget Cutt Daniel Graffort. *Patch Collection, Strawbery Banke museum, Portsmouth, New Hampshire.*

decisions, the records of their lives are scant or nonexistent. Bridget's wealth and widowhood allowed her a level of power most women did not attain, but it was the legacy of her public spirit that allowed her to step beyond the anonymity of her colonial womanhood into the history books of this small seaport town.

As a widow, Bridget had the right to own property independently. Her ownership of a large amount of land north of Market Square in the present-day downtown area enabled her to leave a gift of land to the town for the building of a new schoolhouse. The year before her death, "in the Thirteenth yeare of the Reinge of our Sovereign Lord William the Third," she gave land for a new school and a right of way through her property to the river, granting the town present-day Daniel Street because of the "love and affection I beare unto the Towen of Portsmouth…the place of my birth."

After Bridget's death, the distribution of her land among her many nieces resulted in the division of large fields into smaller lots, which ultimately allowed for the future development of Portsmouth's commercial area. Her wealth and public spirit inspired both the philanthropic act of donating her land and the further division of her estate, which would provide her a place in Portsmouth's history.

Bridget Cutt was born in 1651 to Richard and Eleanor Cutt, English colonists living in a small settlement at the mouth of the Piscataqua River called, at that time, Strawbery Banke. A 1647 court record reveals that her father had purchased a house there and was involved in "repairing ye same, & fiting them for his occasions." Bridget was the Cutts' second child, following a sister, Margaret, born in 1650.

Her father, his two brothers and his sister had emigrated from Bath, England, in the early 1640s during the English Civil War. Bridget's grandfather was a member of the House of Commons during the reign of Oliver Cromwell, a clue to the family's Puritan affiliations. Shortly after his arrival in the Piscataqua region, Richard Cutt married Bridget's mother, Eleanor, of whom records tell us little more than her first name.

Richard and his brother John soon became involved in the lucrative fisheries at the Isles of Shoals, off the coast of Portsmouth, and made their fortunes in the fish trade. Court records reveal that by 1649, Richard Cutt was exporting a large quantity of fish from the Shoals to Virginia. By the middle of the seventeenth century, as many as five hundred fishermen, mostly immigrants from the West of England, lived at the Shoals year round, harvesting the sea with hand lines and nets and returning to the Isles to process the fish for export.

Ten miles out from the mainland on those barren rocky islands in the sea, cod and mackerel were dried in the sun and packed into barrels to ship to Europe and the West Indies. Merchants John and Richard Cutt made a profit buying from the fishermen and shipping part of the ten thousand quintals, or one hundred weights, of fish exported by midcentury. The Cutts owned several warehouses and outbuildings on Star Island and Smuttynose, as well as fish warehouses in Portsmouth.

Their involvement in the fish trade provided the Cutts with the capital to purchase large quantities of land along the Piscataqua River. By midcentury, Richard Cutt had come into possession of the Great House at Strawbery Banke, very likely the house he was repairing. The Great House was a large, palisaded structure built in 1631 as one of several outposts on the Piscataqua for the Laconia Company's New World trading ventures. It stood overlooking the river at what is today the corner of State Street and Marcy Street and was the childhood home of Bridget and her sister, Margaret. The family later moved to a new house near the North Mill Pond.

Bridget grew up in a society shaped both by its roots in medieval English tradition and the religious influences of Puritan and Anglican belief, influences that competed for power in seventeenth-century Portsmouth. In contrast to the Puritan homogeneity found in most Massachusetts towns, Portsmouth by midcentury was a mixed society of both Anglicans and Puritans, fishermen and merchants, as well as a mix of Scottish, Welsh, English and enslaved Africans. At the time of Bridget's birth, the scattered group of fifty to sixty families living along the Piscataqua River was beginning to organize as a community.

The Colony of Massachusetts had asserted political jurisdiction and Puritan influence over the predominantly Anglican province of New Hampshire since 1641, after the dissolution of the Laconia Company. The Laconia Company, headed by Captain John Mason and Sir Ferdinando Gorges, had planned to profit from the abundant raw materials of the region. It had built "Great Houses" at strategic spots to provide bases for the harvest of the region's lumber, fish and furs. The economic failure and dissolution of the Laconia Company left those who had started to make lives for themselves in the Piscataqua region squatters on the land without any political power.

In 1653, in an effort to attain political protection and local control over the settlement at Strawbery Banke, the colonists, led by Richard and John Cutt, petitioned the General Court of Massachusetts to change the name from Strawbery Banke to Portsmouth and to establish an official township.

In 1660, most of the remaining common lands of Portsmouth were divided and allotted in accordance with the wealth and status of each adult

inhabitant. Those already at the top of this economic scale, such as Bridget's father, were awarded several hundred acres, while those at the bottom were allotted thirteen. In this well-ordered, seventeenth-century society, daily life was conducted according to this hierarchy.

Seated in the meetinghouse according to rank, everyone knew his or her place in this close-knit community. Those of highest economic status were seated nearest to the pulpit, symbolic of their proximity to God. Women gained their status and power through male relations and marriage. Bridget Cutt grew to adulthood in this hierarchical, patriarchal society, and because her influence was relegated to the private sphere of home and family, her story lies hidden beneath the actions and adventures of her father, uncle and husbands who appear frequently in the public record.

As a young child, Bridget must have been quite familiar with the Puritan religious doctrine of predestination that equated material success in this world with God's grace and salvation in the next. Her Sundays were spent with her sister and parents at meeting, in their private family pew in the corner of the meetinghouse, listening to the sermons of the Reverend Joshua Moody.

By 1658, Puritanism held sway in Portsmouth, and the Reverend Moody had come to town to serve as minister of the new meetinghouse at the South Mill dam. Bridget's father, a town selectman, was quite influential in the building of this new structure described in town records as "40 feet square, with twelve windows, 3 substancial [sic] doors and a complete pulpit." A twelve-foot cage stood nearby, equipped with stocks, a warning to all of the punishment inflicted on those guilty of smoking tobacco or sleeping in on the Lord's day. Passing the meetinghouse, Bridget might notice a wolf's head grimly ornamenting the façade, nailed there by someone in pursuit of the five-pound bounty for wolves awarded by the town.

"Considering that man's life is short and his end often times sudden," as he wrote in his will in 1675, Richard Cutt left to his "beloved daughter Bridget" the land that would later become her legacy to the town of Portsmouth. This document not only reveals the family's immense wealth but also gives us an idea of the hubbub of domestic activity surrounding Bridget's home, listing a bake house, brew house, barn, log warehouse and wharfing, stone warehouse, tan yard and corn mill among other structures.

In this pseudo-English manor on the banks of the Piscataqua River worked five "negro slaves," mentioned in the will, providing, along with several servants, the much-needed labor for the procurement, processing and storage of food for the household's daily existence.

There was plenty of work to be done by slaves, servants and even children, such as Bridget and Margaret, on this large farmstead. There were cows to tend and milk, butter to churn, gardens to plant and apples to pick for the barrels of English cider needed to last the year. Corn, rye, oats and wheat were cut and dried and brought to the mill to be ground into meal. Hides were cured and dried in the tan yard to provide leather for boots and buckets. Bread and pies were baked in the wood-heated ovens of the bake house to provide for the large household.

Bridget and Margaret had their own chores to do in preparation for the time when they too would have a house full of servants to manage. As a child, Bridget learned certain tasks expected of all women in this era: to cook, make clothing and sew both plain and fancy. Yet, as a daughter of the privileged Cutt family, she also learned to read and write. As an adult, she would sign her name to documents in an era when most women, and many men, simply marked an x for their signature.

Education was a priority in Bridget's family, and in 1669, her father, uncle and Reverend Moody took up a collection in Portsmouth for Harvard College, pledging an annual gift of sixty pounds after "the loud groanes of the sinking college, in its present low estate, came to our eares." That same year, Richard Cutt took charge of the construction of Portsmouth's first official schoolhouse, setting the precedent for his daughter Bridget's support of education in the town a few decades later.

Bridget may have realized that it was not only her wealth but also her education that separated her from those like Philip Bendel, a servant on her father's farm who challenged the norms of acceptable Puritan behavior when he was caught "swearing & taking ye great name of God with bloody Execrations." For this "abuse to his master & for his uncivill carriage in ye family to ye ill example of servants," he was sentenced to be "whipt ye number of twenty stripes."

During Bridget's lifetime, whipping and confinement in stocks or the cage by the meetinghouse were common punishments performed publicly to maintain order in the community. This imposition of external order invaded even the privacy of home when tithing men were appointed in Portsmouth's town meeting in 1678 to "inspect their neighbors, as the law directs, for preventing drunkeness and disorder...and profanation of the Lord's day." The English tradition of taking tithe, the appointment of one head of household in every ten to oversee the proper behavior of the others, was an attempt to maintain Puritan order in Portsmouth.

On the second day of February in 1671, Richard Cutt gave a dwelling house in the "great field" and an adjoining parcel of upland to Thomas

Daniel of Portsmouth "in Consideration of the Love & Affection, he bareth unto the said Thomas Daniel & also for that he hath married his Daughter Bridget." Bridget was approaching twenty years of age when she accepted Mr. Daniel's hand in marriage. Were "those Rings that were Sent to me out of England as Tokens" or the "best stoned ring" listed in Bridget's will signs of their courtship and marriage? It seems likely, as thirty years later in that document, she left her "best stoned ring" specifically to his nephew.

After the marriage, Bridget's husband was granted a license to sell wine and liquor to the fishermen he employed. Like her father, he was involved in the fish trade and owned a warehouse on the banks of the river. Thomas Daniel was highly regarded in the town and was appointed to sit on the "Jury of Trialls" at the "Countie Court" that met periodically in the major towns and later served as a town selectman.

With rings on her fingers, clothed in her silk riding gown and hood, Bridget cut the figure of an English gentlewoman as she rode sidesaddle through the town. Her newly acquired status as a married woman elevated her in the eyes of her family and neighbors. The probate inventory taken thirty years after her marriage lists a sidesaddle, sky-colored satin and silver petticoats, black feather fan and sable tippet (fur cape), very much the wardrobe of a fashionable lady and member of the Portsmouth gentry.

Her dark-colored, red silk gown and gold-fringed petticoat displayed her status to all who viewed her in an era when clothing revealed wealth and social standing. Although it does not appear that sumptuary laws limiting lavish spending were enacted in Portsmouth, Massachusetts Bay Colony had passed measures that codified dress, fining both women and men for the act of wearing clothing above their station.

By the time of Bridget's marriage to Thomas Daniel, Portsmouth was a fortified city preparing for battle against former stewards of the land, the Wabenaki. Relations with the native peoples had been relatively peaceful up to that point, but as land needs were expanding, settlers began infringing on Native American hunting grounds. Construction of a new fort on Great Island (New Castle) at the mouth of the Piscataqua River had been planned in 1666. Subsequently, any ship that sailed into Portsmouth Harbor was required to pay a tax of a half pound of gunpowder "towards the provision of publicke fortification."

A militia had also been formed years earlier and met regularly for training. Bridget was probably relieved when, in 1672, her husband, feeling "so infirme in his body," could not accept his appointment "to the troop of horse under the conduct of Robert Pike." Although two years later, just in

time for the outbreak of King Philip's War, Thomas Daniel was appointed captain of the "foote" company.

King Philip's War broke out in southern New England in June 1675. Under the leadership of Philip, the sachem of the Wampanoags, native tribes and colonists fought each other along the frontiers of Connecticut and Massachusetts. By autumn of that year, the Wabenaki of northern New England were making sporadic raids at Oyster River, Salmon Falls, Newichawannok and Sturgeon's Creek, traveling a route through Durham, Rollinsford, South Berwick and Kittery while circling closer and closer to Portsmouth.

In mid-December, four feet of snow lay on the ground, and Bridget and Thomas Daniel prepared for a long, cold winter. Bridget's wool petticoats and red lined cloak could not have kept her from cold during one of the most severe winters recorded in the seventeenth century. The cold brought a welcome reprieve from attacks by Native Americans, but by the following September in 1676, her husband had joined Richard Waldron in the stunning capture of four hundred Native Americans when he invited them to participate in a mock battle at the Cocheco River in Dover.

A letter sent at the time from Portsmouth to the governor in Massachusetts reveals these trying times in the Piscataqua: "Only this much we have learnt yt ye Enemy is Numerous…that he is proceeding towards us and so on toward yourselves ye Enemy intimates & ye thing itself speaks." Six men signed their names in ink below. Three besides Thomas Daniel were related to Bridget, revealing her very close involvement in the ominous situation. She and her husband and the inhabitants of Portsmouth lived with the constant threat of attack and retaliation.

In October 1676, Thomas Daniel received orders to "impress such vessels as are needful with amunition and provision, and what may be necessary for the designe who are going to Blacke Pt. Winter Harbor etc. for the recovering & securing of those places, and distressing and destroying the enemy there or elsewhere." It must have been hard to say goodbye to her husband as he sailed off to Winter Harbor at the mouth of the Saco River in Maine. As Bridget prepared for the dark, cold nights of winter in those fearful times, she must have found reassurance in her many relatives living nearby.

Her sister, Margaret, had married William Vaughn and lived a short walk away with her several small children. Her mother, Eleanor, and her uncle John Cutt and many cousins lived by the North Mill Pond. In times of peace, she could travel by horseback and boat to visit the aunts, uncles and cousins scattered farther away at Great Island, Kittery and Dover. With no children

of her own, Bridget must have sought support and companionship in her extensive family.

Thomas Daniel was forty-nine years old when he died in November 1683. He had been in "perfect memory though much indisposed" when he composed his will a few days before his death, leaving to his "dearly beloved Bridget Daniel" all his "Worldly Estate." It's not hard to imagine that after thirteen years of marriage, Bridget clothed herself in black and prepared to walk behind her husband's coffin in the funeral procession from their house to his newly dug grave. As his body was laid to rest at the Point of Graves, Bridget perhaps felt a tinge of pride from beneath her sadness as the Reverend Joshua Moody lauded Thomas's strength. Her husband dead and buried, Bridget was left behind to grieve in her black silk gown and mourning hood.

To his kinsman Thomas Graffort, Thomas Daniel left one hundred pounds English sterling. Mr. Graffort, a prominent Portsmouth merchant, wore a sword and carried a silver-headed cane and, as her husband's cousin, was a very suitable prospect for Bridget. After a year in black clothing mourning her first husband, Bridget Cutt Daniel, age thirty-three, took Thomas Graffort for her second husband. A record of his license to dispense liquor as part of wages for his "lumberers and fishermen" reveals her new husband's involvement in the fish and lumber trade.

He, too, was involved in the militia, riding out to the house of John Sherburne at the Portsmouth Plains "with horse, sword, pistol, powder and shot" to practice in January 1684. His appointment to the governor's council in 1692 reveals his standing in the community.

Thomas Graffort also became a leader in the defense of the town. A 1694 town record of gunpowder being allotted to several garrisons includes a portion to "Mr. Graffort's Fort." The massacre of three hundred colonists at York, Maine, in a Native American attack on Candlemas Day, February 2, 1692, emphasized the need for continued vigilance in Portsmouth. The danger came very close to Bridget in 1694, when her aunt Ursula Cutt and three of her hired men were killed at her farm two miles upriver following a bloody early morning attack when close to one hundred settlers were killed or captured.

Bridget's husband's fort and his involvement in the militia perhaps made her feel secure, and it must have been reassuring to have the three hundred pounds of shot, six muskets and swords, cutlasses and blunderbuss listed in her probate inventory. This large supply of ammunition might signify that their house was fortified as a garrison like others in Portsmouth or that Mr. Graffort had transformed an outbuilding or warehouse into his own fortress.

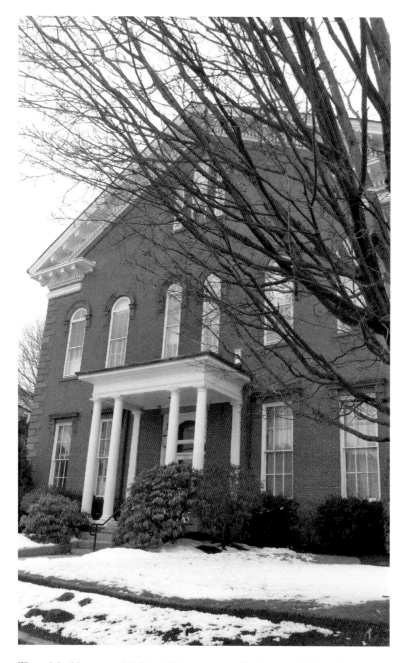

The original house on this Daniel Street site was the home of Bridget Cutt Daniel Graffort, who bequeathed her Graffort's Lane (renamed Daniel Street) to the city, a strip of land connecting Market Square to the river. *Photo by Laura Pope.*

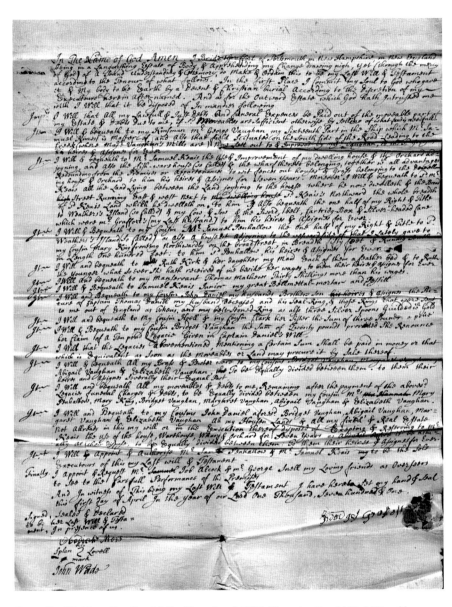

The will of Bridget Cutt Daniel Graffort, dated 1693. Photo by Gerald H. Miller. *New Hampshire State Archives, Concord, New Hampshire.*

In 1697, Bridget became a widow once more. Remnants of Mr. Graffort's involvement in the fish trade—thirty hogsheads of salt, five pairs of long spruce oars, a paper of mackerel hooks and more than forty wooden shovels—were left shut inside the warehouse by the river. In her widowed state, with just herself and her two servants to provide for, Bridget kept only one cow and a sow to provide her with the beloved dairy products and pork of the English diet.

Through her ownership of one-sixteenth share in a ship called the *Barbadoes Merchant*, Bridget stayed involved in the mercantile trade that had built her family's wealth. Did she continue selling cloth and imported goods out of the shop that is mentioned in her inventory? Certainly a "new account book" and the "1 old trunk 5½ yds blue linen, 10 yds of freshen in shop" might be answers to this question.

At the end of her life, Bridget Cutt Daniel Graffort lived on what is today Daniel Street in a two-story house with an adjoining orchard. Hers was a home of Portsmouth's upper class, with a hall, parlor, entry porch and kitchen on the first floor and bedchambers upstairs. On the walls of this house hung a landscape painting and a still life of fruit along with a map of Rome and a portrait of her first husband. A dozen Turkey-work chairs sat around the large table in the parlor, which, in seventeenth-century fashion, was draped with a "large Turkey-work carpet." There was also listed in her inventory "1 silk cradle quilt" stored in a cedar chest, perhaps the buried memory of a baby who had not survived or the forgotten hope of the child she never had.

Lying in her featherbed "in a Languishing Estate of Body," Bridget could hear the oxen with loaded carts going by on the road in front of her house and then down to the wharf at the river's edge. In her fifty years, she had seen the town grow from a small rural settlement of sixty families at Strawbery Banke to a bustling seaport of more than two thousand people. She had lived through wars with the native tribes and known great sorrow, as her sister, parents, great-aunt and two husbands passed to the grave before her. Her nieces and nephews had been of great help and comfort in her widowhood, and she left to them most of her estate.

She had compiled an estate valued at more than £1,300 in a time when most were worth £200. To her little neighbor, Samuel Keais Jr., she left her "great Bell-metal mortar and Pestill"; perhaps as she lay there she could still picture him grinding cinnamon for her in the kitchen. She would miss them all, but her faith sustained her hope that she would now join God's elect in heaven.

Allice Shannon Hight, 1715–1780: Eighteenth-Century Mom and Tavern Keeper

BY ELIZABETH P. NOWERS

The life of Allice Frost Shannon Hight, a successful tavern keeper who resided in Portsmouth, New Hampshire, in the eighteenth century, casts a revealing glimpse at life in colonial America and how circumstances propel some women into active public life.

Telling her story involves putting together her life from bits and pieces of information, much as making a quilt involves sewing together fragments of cloth. Her name, spelled in many different ways, appears on a list here and a deed there. She married, had children, went to church, appeared in court, married a second time and, slowly, details of her life may be pieced together. In this way, Allice becomes a real person who lived and worked in Portsmouth more than two hundred years ago.

Allice initially appears in Portsmouth records at the time of her first marriage. The entry by the town clerk reads: "Nathaniel Shannon of Portsmo and Allice Frost of New Castle wr marryd Novr ye 10th 1737." Allice was the daughter of Samuel Frost of New Castle, a mariner. Although no birth records for Allice have been found, she was probably born around 1715 as most women in New England married in their early twenties. Nothing is known about her mother, and there is no evidence they were related to the well-known Frost family of New Castle and Kittery, Maine.

It seems the Frosts were neither as socially prominent nor as wealthy as the Shannon family. As there is no probate record for Samuel Frost, who died before 1770, his estate was likely small.

Allice married well, for her husband Nathaniel, born in Portsmouth on February 17, 1715 or 1716, was the son of Abigail Vaughan and Nathaniel Shannon. His father was a shipping merchant who died in the West Indies before 1723. His mother, Abigail, was the daughter of William Vaughan, a royal councilor and chief justice of the Superior Court of the Province of New Hampshire. In 1735, Abigail married a second time to Captain George Walker, a wealthy and eminent Portsmouth citizen. Allice's mother-in-law, Abigail, was a contentious woman who would involve Allice in rounds of legal battles throughout her life.

Portsmouth records reveal that Allice's husband Nathaniel was an innkeeper. Tavern and innkeepers presided over an important public place in the eighteenth-century community. Besides providing food and lodging for strangers and travelers and hay, grain, pasturing and stable room for their horses, taverns were gathering places for townspeople. Auctions, sales, exhibits and lotteries were frequent events. Travelers brought news from other towns and carried letters and newspapers, making the tavern an essential source of information. Since many people visited taverns, the government expected the proprietor to be a person of good character and able to keep order.

To ensure this, a tavern keeper was granted a license by the governor and council only after being recommended by the town selectmen. Tavern licenses could be denied or, if already issued, revoked. Portsmouth, the capital of the province of New Hampshire until 1775, had many taverns. Various taverns served as the meeting rooms for the government until the early 1760s, when the state house was built in Market Square.

Nathaniel Shannon's daybook for the years 1731 to 1744 is preserved in the collection of the New Hampshire Historical Society in Concord. The accounts show that as a tavern keeper, he was making and selling cider, renting horses and providing food and lodging. His tavern included shop space as he was also buying and selling dry goods and provisions including such items as cloth, tobacco, candles, indigo, hemlock boards, meats and fish. As he was also buying and selling hides, saddles and bridles, Nathaniel seems to have been working as a tanner as well.

Furthermore, the 1754 inventory of his property lists "$\frac{1}{2}$ part of a Lott of Land in Islington…an Old Tanyard." Islington was the area around the North Mill Pond, then called Islington Creek. Although the location of Allice and Nathaniel's home at the time of their marriage is unknown, it is clear from the daybook they were operating both a tavern and a shop in Portsmouth, possibly at the site of the tan yard.

Allice and Nathaniel had four children in the first six years of their marriage: George Walker, named after his grandmother's second husband, baptized on July 23, 1738; Nathaniel, baptized on April 20, 1740; Abigail, baptized on March 7, 1742; and Margaret, born around 1743. The Shannon family attended the South Meeting House, located on Meeting House Hill (the previous site of the Children's Museum of New Hampshire), where the children were baptized. Nathaniel became a full member of the church on the same day his son George Walker was baptized.

In 1746, Nathaniel and Allice Shannon purchased from Samuel Alcock, boat builder, a lot of land and all the buildings thereon, "located on the easterly side of the street leading to the north part of Town by the dwelling house of Eleazer Russell," for £375. This lot was on the Piscataqua River, about where the Isle of Shoals Steamship Company dock is today.

The fact that the deed is in both Nathaniel and Allice's name is unusual. In the eighteenth century, most property purchased during a marriage was in the husband's name only. Why the Shannons' property was in joint ownership is a question without a ready answer. For Allice, it was an exceedingly good arrangement as it resulted in her holding sole title to the property after Nathaniel's death. If the deed had been in Nathaniel's name alone, Allice's only claim to the property would have been her dower right; she would have had the use of only one-third of the property for the remainder of her life.

The purchase of this property provided the Shannons with an ideal location for a tavern. The property was on the waterfront near or next to the ferry that crossed the Piscataqua River to Kittery. Travelers came and went at all hours, stopping at the tavern to wait for the ferry. Allice was surely involved in the tavern operation, overseeing the cooking and housekeeping. When Nathaniel was away, she might have also dispensed beverages and recorded customer purchases. The children, as they got older, were expected to work in the tavern.

Like many prosperous Portsmouth residents in the eighteenth century, the Shannons also relied on the labor of slaves. A negro man named Prince and a woman called Diana were listed as the property of Nathaniel in his inventory.

Nathaniel became a member of St. John's Lodge of Masons the same year the Shannons purchased the waterfront property. This could only help the tavern business, for as a Mason, he would socialize with many of Portsmouth's most prominent citizens, including Governor Benning Wentworth.

Perhaps the move to the tavern on the north end of town inspired the family to begin worshiping at the North Meeting House instead of the South

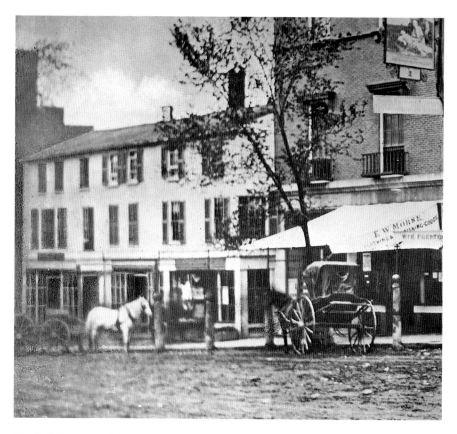

The Bell Tavern, built in 1743 on Congress Street, like the Bunch of Grapes, was one of fifty-eight taverns in operation in Portsmouth before the American Revolution. *Patch Collection, Strawbery Banke museum, Portsmouth, New Hampshire.*

Meeting House. The North Meeting House was in Market Square, a short walk from the tavern. In a deed dated July 9, 1749, Nathaniel purchased a pew for the family's use. Allice, however, did not become a member of the North Meeting House until June 7, 1778.

In 1753, Allice became a widow. Nathaniel Shannon died at age thirty-eight, leaving Allice to provide for herself and their four children. It is probable that the boys—George Walker, about fifteen years old, and Nathaniel, about thirteen—were apprenticed to learn a trade. The girls— Abigail, about eleven, and Margaret, age ten—were still at home. Allice, because she held title to the tavern property and knew the trade, was in a good position to take over the business. She quickly applied for the tavern license in her own name.

In September 1753, the selectmen wrote to the council that "we approve of Mrs Allice Shannon as a suitable person to keep a House of Public Entertainment in the House where she now lives."

Female tavern keeping was not uncommon. In fact, it was an occupation widows traditionally pursued to support themselves. Historian Kenneth Scott lists fifty-eight tavern license holders in Portsmouth before the American Revolution, and sixteen, or about 38 percent, were women.

While her children were still minors, Allice had the labor of slaves Prince and Diana, who continued to do most of the heavy work in the tavern. On January 12, 1754, Allice, perhaps to improve her chance of success as a tavern keeper, purchased from Margaret Chambers, widow of Charlestown, Massachusetts, a tract of land known by the name of Madam Bridget Graffoort's Common, located near a place commonly called Gravelly Ridge. This land, located on Woodbury Avenue, consisted of about sixteen acres and was possibly used as hay field or pasture. Either would be a valuable addition for a tavern keeper to provide fodder for travelers' animals and the family cow.

After Nathaniel's death, Allice was named administrator of her late husband's estate. The estate was inventoried and presented to the probate court on January 30, 1754, and was valued at £1,404.14. Unless there was a will, an estate was divided so the widow would receive one-third of the personal property. Of the remainder, the oldest son would get two shares, and each of the other children would receive one share. In this case, Allice would administer the estate until each of her children reached legal age, which was twenty-one for the boys and eighteen for the girls. They would then receive their shares.

Half the estate's value was in the slaves—Prince, valued at £400, and Diana with a child, valued at £300. Unfortunately for Allice, the probate of Nathaniel's estate was contested by her mother-in-law. The same day the inventory was presented to the probate court, Nathaniel's mother, Abigail Walker, claimed "that some part of the Estate Contain'd in the said Inventory is not nor ever was the Estate of the said Nathll vizt a Negro Woman named Diana & her Child named Phillis which are the Proper Estate of the said Abigail." She then asked the court to remove them from Nathaniel's inventory. While the probate records do not indicate the outcome of Abigail Walker's claim to the slave Diana and her child, it appears from later court records that Diana was not returned to Abigail. Allice and her former mother-in-law might have been at odds for the rest of their lives.

Possibly because of this contention over Nathaniel Shannon's estate, Allice married for the second time early in 1754. Her new husband, Charles Hight of Portsmouth, was a sail maker with property on Bow Street. He was also a widower with five children: Charles, age thirteen; Andrew, age ten; Sarah, age seven; Elizabeth Mayberry, age five; and Christopher Culling, age three. In late 1754 or early 1755, the Hight family gained another member when Samuel was born. He was baptized at North Meeting House on January 12, 1755.

With her marriage, Allice surrendered legal control of her property to her husband during his life. The selectmen wrote the council on September 2, 1754: "Content that Mr Charles Hight should keep a publick house In this Town for this present year." Portsmouth historian Ray Brighton notes that though Charles Hight was a sail maker, he may have been the proprietor of an inn called the Bunch of Grapes as well.

There is no evidence Charles operated a tavern before his marriage, so the tavern he was licensed to operate was most likely Allice's. She was probably still actively involved in its operation as well as running a greatly expanded household.

Although not a Mason, Charles had been more active in town affairs than Nathaniel Shannon. He had been elected constable in 1753 and was a provider of goods to the Town of Portsmouth.

The Hight family prospered. By 1755, Charles was being paid by the selectmen to operate the ferry to Kittery that was next to the tavern. The taxes paid to the town and province increased from eight pounds in 1755 to just over twenty-five pounds in 1760. Charles was elected fire officer in 1756. From 1757 to 1759, he was elected a fire ward, the person who directs the actual firefighting.

In 1758, Charles Hight and Allice became ensnared in Abigail Walker's continuing legal actions. As Allice's husband, he was ordered to appear in court because Abigail Walker had accused him of persuading the negro slave Diana to run away. (This is the same slave listed in the inventory of the estate of Nathaniel Shannon.) Abigail Walker claimed £200 in damages from Charles Hight for the loss of Diana's labor for the four years between 1754 and 1758.

The case was further complicated by Abigail's son, Cutts Shannon, who added a claim of £1,608 against Nathaniel Shannon's estate. Charles was the defendant because his wife, Allice, was the administrator of her first husband's estate. After waiting a year, both Abigail and Cutts must have been disappointed by the court's award. Abigail received a settlement of

just over £25 and Cutts the sum of just over £2, plus the cost of court. The surviving court records unfortunately do not indicate the fate of the slave, Diana.

The February 13, 1761 issue of the *New Hampshire Gazette* carried the notice of Charles's death by pleurisy fever. Published death notices for ordinary people are rare in the eighteenth century. The fact that his death was announced in the newspaper implies he was considered an important member of the community.

Once again, Allice's life was altered. In her mid-forties, Allice was named administrator of Charles's estate, which was valued at approximately £9,000. Included in his inventory are several slaves, a large boat, the contents of a dry goods shop, household goods and many personal items such as clothing, his watch, sword and "two wiggs."

While Allice's older children began to reach adulthood, she still had several young children to support: her son Samuel Hight and stepchildren Sarah, Elizabeth and Christopher. The tavern, where the family continued to live, would be Allice's main source of income. As administrator of Charles's estate, Allice probably rented out the house, land, barn and wharf on Church Hill (today's Bow Street) for additional income. She would have the labor of Charles's slaves for work in the tavern while his children were still minors. Allice also took over the operation of the Portsmouth and Kittery ferry.

In December 1761, Allice Hight was paid more than seven pounds on account by the selectmen for administration of the ferry service. Allice did not run the ferry for long. In 1762, her son Nathaniel was paid by the selectmen for its operation.

At about this time, Nathaniel married Ann Card of New Castle. Allice's first grandchild, Margaret, was baptized at the North Parish Church, February 27, 1763. If Nathaniel was still operating the ferry, his family was probably living at the tavern.

In a history of the Shannon family, Allice's oldest son, George Walker Shannon, is listed as having died unmarried in early manhood. As he does not appear in any of the extant records, he had probably passed away by this time.

In 1762 or 1763, her stepson Charles, a sail maker like his father, came of age. Allice purchased Charles's share of his father's estate in March 1763. Charles, as the eldest son, had a double share, which included part of the Bow Street property. While this portion of the estate cost Allice £1,545, the purchase allowed her to continue to receive all the rental income from the property.

With the 1762 death of Allice's former mother-in-law, Abigail, Allice again became involved with the courts, this time to implicate her former brother-in-

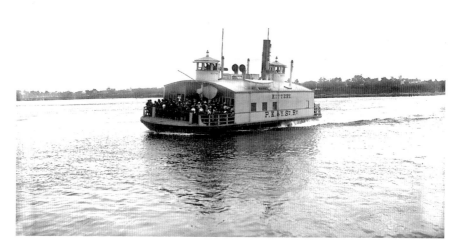

Portsmouth-to-Kittery ferries were vital transports for centuries in Portsmouth. *Patch Collection, Strawbery Banke museum, Portsmouth, New Hampshire.*

law, Cutts Shannon. In a will dated 1756, the cantankerous Abigail left five pounds to each of her grandchildren. Her son, Cutts Shannon, was heir to the remainder. The estate was sent to probate and approved October 29, 1762.

On June 13, 1763, on behalf of her children, Allice petitioned the probate court to disallow the decision, claiming she could not contest the will because the probate was conducted without proper notice. Her right to appeal was granted, and a month later on July 13, 1763, Allice presented to his Excellency Benning Wentworth, Esq., the governor, and the honorable council a petition with two reasons why the will should be disproved. First, Abigail was old and senile at the time she was supposed to have made her will, and second, the will had been altered after Abigail died.

The governor and council agreed to hear her case in October 1763 and ordered Cutts Shannon to be served with a copy of order. While the final decision of Allice's case is not found in the packet of documents at the New Hampshire Archives, the original will is. As Allice wrote, there was a "very material alteration" in the will. A hole was cut out where the amount of the settlement to Allice's children was written and a piece of paper with the word "five" pasted into the space.

The tavern continued to do well. In the list entitled "Excise [tax] assessed of Portsmouth Taverners and Retailers from Sept. 1764 to Sept. 1765," Allice was assessed and paid just over ten pounds in tax. This is almost as much excise as was paid by Portsmouth's most prominent innkeepers. James Stoodley, who operated the King's Arms, paid just over fourteen pounds, and John Stavers, owner of the Earl of Halifax, paid about twelve pounds. The following year, Allice again paid the third highest excise tax in Portsmouth, although the amount is less, at eight pounds and eight shillings. This decline in tax may be the result of adverse economic conditions in Portsmouth, as James Stoodley also paid less, or possibly, Allice began to contract her business interests as her family responsibilities lessened.

The youngest of Allice's stepchildren, Christopher Culling Hight, turned fourteen in 1765. In a document dated October 31, neighbor George Boyd, an important mariner and shipbuilder in Portsmouth, was appointed Christopher's guardian. As guardian, he would supervise Christopher's apprenticeship and take over the responsibility for his support.

By 1765, Allice's daughters were adults. Although the exact dates are unknown, both daughters were married by the mid-1760s, Abigail to George Bryant, a mariner, and Margaret to Captain William Parker, a shipmaster. While Allice no longer had to provide for her daughters, she lost their labor at the tavern, and she may have lost the labor of her enslaved help as well. With the coming of age of her children and stepchildren, their fathers' estates would have been settled with the personal property, including slaves, distributed to the heirs.

As Allice's household shrank, so did her need for income. Tavern keeping involved a great deal of hard physical labor, labor that her family provided. Allice does not appear to have enlarged her business. In the years 1765 to 1768, the amount of taxes she paid to the town and the province remain unchanged. By 1769, she had probably closed the tavern, as she paid no taxes.

She continued, however, to own property and, in fact, extended her holdings. On December 19, 1769, Allice purchased from her stepson mariner Andrew Hight his share of his father's estate for fifty pounds.

Allice's last purchase of property was from her stepson mariner Christopher Cullin Hight on October 29, 1774. She paid thirty-five pounds for "one full seventh part" of his father's estate. With this purchase, Allice owned the entire Bow Street property.

These properties provided her with rental income. As there is a spinning wheel listed in her inventory, the ever-industrious Allice may have been

spinning to provide extra income. She also owned two cows at the time of her death, so she may have been selling milk or butter. This would have been enough income to support a single person; however, from evidence found in her estate records, Allice was not living alone. Nathaniel was listed in the records as a boat builder and was probably using the property as a boat yard. His family lived at the former tavern with his mother.

Allice died in 1780, and Nathaniel, her only surviving son, was named administrator. Her estate, which was inventoried May 17, 1781, consisted of the house and land near the ferry, the house and land on Bow Street, a lot of land near the head of Islington Creek and almost seventeen acres at Gravelly Ridge, as well as household goods. The monetary upheaval caused by the war with England made settling the estate complicated and time consuming.

As Allice's personal property was not valuable enough to cover the demands against her estate, some real property had to be sold. The land at Islington was sold in June 1783. A second sale of real estate took place on January 18, 1786, when Supply Clapp purchased the property near the ferry for £325. The purpose of this transaction was to remove the property from the estate, as Nathaniel purchased the property the same day for the same amount. The estate was finally settled in May 1787, with the division of the remaining property among Allice's three surviving children. Nathaniel, for his two shares as only son, received the land at Gravelly Ridge and half the property on Bow Street. George Bryant and William Parker, representing daughters Abigail and Margaret, each received one-quarter of the Bow Street property.

Allice had done what she had set out to do by becoming a tavern keeper. She was able to provide for herself, her children and her stepchildren after the death of her husbands. The fact that she was successful was a combination of her good fortune and ability.

Sarah Haven Foster, 1827–1900: Grandmother of Portsmouth Tourism

BY MARYELLEN BURKE

T he twentieth century killed Sarah Foster.
On August 19, 1900, an unscheduled electric trolley car struck and threw Sarah several feet from the road after she hit the fender; she died later that evening of shock and internal injuries. The seventy-three-year-old woman, hard of hearing and with bad eyesight, had been crossing Middle Street at Richards Avenue in front of her home. "It was a thrilling episode, and those that saw it held their breath," reported the front page of the *Portsmouth Herald*. Sarah had known the trolley schedule and actually waited for the first car to pass before stepping into the street, only to be struck by a second trolley. The second trolley had been added that day to accommodate the influx of tourists heading to the beach in Rye.

The woman whose *Portsmouth Guidebook* brought scores of tourists to the seacoast succumbed to the incident. The trolley fatality was the first such death caused by the new "electric cars."

The influx of tourists to Portsmouth was only one of a number of changes that occurred in local society at this time. Electric cars and tourists were part of a number of innovations that changed the landscape of Portsmouth from a commerce- and shipping-based economy to a more industrial and modern one. Sarah Haven Foster lived through these changes and, rather poignantly, died from them.

Much of Sarah's existence in the last twenty-five years of her life was dedicated to documenting and preserving an older, romantic sense of Portsmouth. She established herself as the grandmother of tourism for

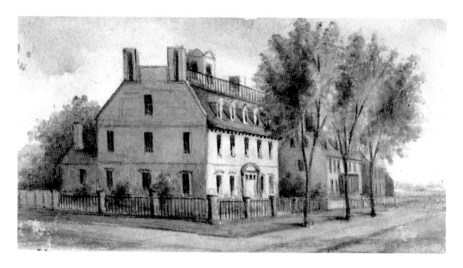

Warner House by Sarah Haven Foster. *Portsmouth Public Library, Portsmouth, New Hampshire.*

Portsmouth when she wrote the *Portsmouth Guidebook* in 1876. It was so popular that it was reprinted in 1884 and 1893. The first of its kind for the area, it was modeled after the guides Sarah saw in her European travels. Unlike Charles Brewster's weighty, armchair rambles of the city, published in 1852, or Nathaniel Adams's cumbersome history, published in 1825, the *Guidebook* was designed to be carried during an actual tour of the city.

The inexpensive book came both with and without a map. Describing six different walks beginning from Market Square, a modern tourist may still walk the streets of Portsmouth with Sarah's guidebook in hand. Some buildings have been removed, but many are the same. The book takes the reader step-by-step around the city.

Much as an audio-tour in a modern museum, Sarah's "voice" guides the tourist to each "exhibit." Published and marketed by her brother, Joseph Foster, the *Guidebook* was successful and became a source book for subsequent guidebooks including Gurneys's *Portsmouth Historic and Picturesque,* published in 1902, and Pearson's *Vignettes of Portsmouth* in 1913.

The *Guidebook* itself is at times almost tedious in detail, but it is full of interesting information on who inhabited the various homes in downtown Portsmouth. In the following passage, Sarah describes the houses on State Street near Pleasant Street where there are now parking lots and banks:

In going down Pleasant Street, you cross two streets that are right angles with it, State and Court Streets. To traverse these, we will first turn to the right, round the corner of the Customs House, into State, formerly Broad Street….Next, beyond this stands the ancient looking Spence House, while on the other side of the street is what remains of the Brackett House, no. 83; at the corner of Fleet Street is the Davenport House.

This walk continues through the State Street section of town. Some of the other five walks bring the reader as far as two miles from Market Square out to Woodbury Avenue. But the main focus of the book concentrates on the block around Market Square.

Although Sarah wrote it, the book was marketed as "published by Joseph Foster." To this day, it is often mistakenly attributed to him. For reasons unknown, the author's identity was not publicized, possibly on the assumption that it would sell better, but that is unclear. Maybe it was Sarah who wanted it this way.

The *Guidebook* and her tragic death are only a small part of Sarah's most interesting life. She was an accomplished painter, poet and world traveler. She came from a family dedicated to community service. A prolific painter, Sarah created thousands of small paintings, many of which can be seen today at the Portsmouth Public Library in the special collections department. The subjects of these paintings go far beyond the little town of Portsmouth.

Sarah, an extensive traveler, frequently toured Europe in summers with her sister, Mary Foster. She also lived in Europe from 1886 to 1890. Her watercolor flower studies are exceptional. She was also a poet of some merit. *Poets of Portsmouth*, also published by her brother, Joseph, contains a number of her poems. Like her paintings, her poems focused on pastoral idyllic subjects such as a cricket and "the Chant of the Ocean."

Religious imagery and explicit religious subjects pervade her other poems as well. Sarah's diverse talents and prodigious output are easily understood in the context of the Foster family. If we look at the life of her father, we also learn why religious imagery would pervade her poetry.

Born in 1827, Sarah Haven Foster witnessed many changes in Portsmouth. Her father, John Welch Foster (deceased 1852), moved here in 1813 and made his name as a bookseller and printer on Market Street. He was an upstanding citizen though not as prosperous as he might have been. It was said that he gave a great deal of his money to needy causes. He was an incorporator of the Portsmouth Savings Bank and sought to help others learn to save and make a way for themselves financially.

He became a deacon in the South Meeting House in 1819 and remained active in the church until his death. His letters to his children reveal a fervent yet individualistic faith. He sought to instill in them a sense of morality and individualism that was anchored in Biblical principles yet not fraught by blind allegiance to doctrine. After marrying Mary Appleton in 1824, they had three children: Joseph Hiller (1825–1885), Sarah Haven (1827–1900) and Mary Appleton (1829–1913). The religious influence of John Foster would pervade the concerns of his children throughout their lives. It is worthwhile examining his influence a little closer to see how it impacted Sarah. The following letter written to Sarah represents his individualistic Christianity. This quote is taken from a book written about John Foster by Reverend Andrew Peabody:

> *Many of our own denomination again seem to think that it is all in all to feel right; and therefore address the feelings, and paint beautiful theories, rather than urge the conscience to a holy life, to right and consistent action.*

Conscience, Foster insisted, which brings forth right action, was of utmost importance, more so than feelings. Evidence of "acting right" can be found in many of his letters to his children. Here, his letter continues to urge Sarah to be good through good habits:

> *Thus we may go on…until nothing which is unholy can give us pleasure… This is to be good. Then good feelings and good actions come of course… no reasoning is required to call them forth.*

A fervent dedication to community values and to a specific way of life is evidenced in the particular activities chosen by the Fosters. Life was made for service and action. Communities were warm and helpful places ordered by a benevolent upper class. More than rhetoric of good works—which by all indication was put into real action—the Fosters also cultivated a sense of nostalgia for a way of life that was rapidly passing away.

It was a pastoral vision of society where those who were well off committed themselves to serving the less fortunate through their avocations. John Foster, his son, Joseph, and daughter Mary dedicated themselves tirelessly to various and diverse community causes. Sarah's mother's work is mysteriously absent from public record. Once widowed, Sarah's mother, Mary, lived with her daughters on Richards Avenue until her death in 1879. Unfortunately, not much more is known about the older Mary Foster, except that she was

always held in high esteem. Joseph's obituary in 1885 reads like his father's in 1852, full of references to the benevolent societies, the school committee, the Portsmouth Athenaeum, the Missionary Society and the Chase Home, to name just a few. Mary Foster, Sarah's sister, was the first female treasurer of the South Meeting House and served as a nurse in the Civil War. She was a founder of the Portsmouth Public Library, to mention just a few of her community-building activities.

Though Sarah did not seem to ascribe to her brother and sister's sense of community development and activism, she did contribute to that community in a very significant way. For example, while Mary went to the battlefields of the Civil War and wound bandages, Sarah wrote a poem about the war called "August 1864," which is in *Poets of Portsmouth.*

Interestingly enough, it is Sarah's work that survives to tell us the most about this vision of Portsmouth society. During her lifetime, Sarah's activities may have appeared idle or self-indulgent in comparison with her sister's bandage-making and church work. However, Sarah's efforts to produce works of art have endured. Sarah's paintings of houses, for instance, offer us a wonderful record of what it was like to live in a community such as Portsmouth.

Her house portraits bring to life buildings in a way that monochrome nineteenth-century photography cannot. Like those photographs, her street scenes and houses are often deserted. But unlike the photographs, there is a warmth to the color and softness to the images. They are almost worn and welcoming. As her world changed, Sarah painted the remaining houses in her community with a care and attitude of a romantic archivist.

Sarah's houses appear rustic in an inviting, approachable way. The collection of these paintings creates a remarkable record of what the houses looked like at this time. Sarah frequently gives more than one view. She also painted colonial houses that had disappeared by her time period with the same romantic imagination, using woodcuts and other sources as a reference.

Her soft, appealing style was not quite impressionistic but rather edges closer to realism with a nostalgic gloss. Some of her subjects include views of open land that no longer exist. Her view of the South Cemetery in Portsmouth shows an uncrowded graveyard. Elms near the South Mill Pond, Elwyn House on Elwyn Road and the Dennett House are some of her other subjects. Sarah also traveled farther around the seacoast and inland to paint subjects in Newington, Dover, Hampton, Kittery, New Castle and even the Shoals.

In keeping with the tourism destinations of her time, she went to the Isles of Shoals to paint what she calls the *Wagner House: Scene of a Murder.*

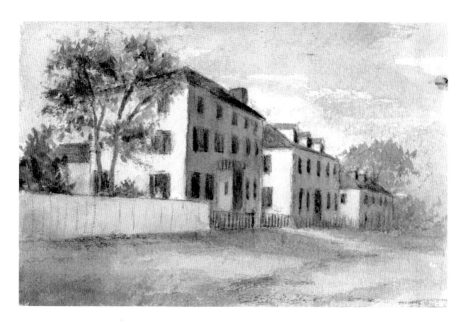

Reverend Sam Haven House by Sarah Haven Foster. *Portsmouth Public Library, Portsmouth, New Hampshire.*

Sheafe-Coffin House by Sarah Haven Foster. *Portsmouth Public Library, Portsmouth, New Hampshire.*

This painting depicts the Hontvet House where the Smuttynose murders occurred in 1873.

Also included in her album are scenes she painted from places farther away, such as New Jersey, New York and Virginia. We do not know with whom she did all this traveling, but these paintings have a very different tone than the ones she did around her home community. The paintings of the Connecticut River and other landscapes are flat in perspective and not as well executed with color. One of her horses in a field is primitive and child-like. Did she actually travel to these places? We do know she spent much of her youth traveling in Europe.

It appears she liked traveling a great deal, especially when she was younger. Her traveling and painting activities may not have initially been supported by her family. Perhaps her artistic tendencies removed her from the public service of her father and siblings. Her family may have had a hard time envisioning how painting and poetry could become an important contribution to public life. At age sixteen, Sarah appeared to be straying from the straight path her father set out for her. He sent his admonition in a letter to her while she traveled in Europe:

> *A few years of neglect or of indulgence in trifling or degrading pursuits, will in the susceptibility of youth, stamp impressions most difficult to efface,—may implant tastes and habits most difficult to eradicate; and years which might have been spent in progress, must be employed in undoing and overcoming the effects of delay. I hope and I trust, my daughter, that you have begun the good course...Be frank and open with us...we can sympathize with all your difficulties. You must not show yourself discouraged by what we point out.*

Was her early artistic energy viewed as a "degrading pursuit" initially? Or her frequent travels to Europe? What did they "point out" that she might be discouraged by? Despite her father, Sarah continued to travel, paint and resist community activities. But no serious dissention is evident between them, just this early discord. Sarah's father died in 1852, long before she wrote the *Guidebook*. In retrospect, it may be easily imagined that he would have approved of its publication.

Her brother, Joseph, having taken over the role of her father in business, certainly did approve of Sarah's literary efforts by publishing and promoting them. Her brother most likely approved of the pastoral worldview that Sarah brought to the public, one that looked back at a grander time in Portsmouth history. Decidedly colonial in approach, Sarah's *Guidebook* and house portraits

do not document for us the older Portsmouth so much as a feeling for that older Portsmouth. As tourists of history today, we can view Sarah's Portsmouth in the light of the competing visions of her contemporaries, such as Frank Jones, who brought modern convenience and development to the city.

The year Sarah's *Guidebook* first came out coincided with the first centennial of America. The celebration of the first hundred years of the country started a trend of nostalgia for an earlier way of life. In architecture, this penchant was most pronounced in the Colonial Revival. Although much of what was revived was imagined, the reference to colonial times did serve to comfort people during a time of great change. The Colonial Revival period, as it is now known, looked back on our past for a sense of security and identity in a rapidly changing and industrializing society. It also renewed a sense of American individualism by referring to a mythological time when individual men created a new country by their sheer willpower, ignoring the contributions of enslaved people, women and others.

As Sarah looked to the past for inspiration, her contemporary Frank Jones looked to the future for innovation. At the time of the publication of the *Guidebook*, Jones was building his industrial empire in Portsmouth. As Portsmouth's own robber baron, he expanded his brewery on Islington Street to serve the increasing numbers of factory workers in the area. He brought such innovations as water lines, icehouses, first-class hotels and even electric trolley cars to Portsmouth.

Frank Jones's works represented the antithesis of Sarah's backward glance. It is easy to imagine that while the whole landscape was changing before their eyes, people such as Sarah would long for a time when things did not change so rapidly. Sarah's travels to the Old World also informed this perspective. She spent a great deal of time in Europe. From there, she acquired an affection for the permanence of things past. Most of her European paintings depict ruins. Surrounded by the timelessness of Europe, she became cynical and dubious of progress.

Her love of history extended beyond colonial American history through her extensive visits to historical sites in other countries. Sarah strove to preserve a piece of the history of the places she visited through writing, painting and even in the souvenirs she sent back to Portsmouth. To a young Wendell cousin she wrote:

> *I promised you if I visited Norway to try to send you a chip of the old Viking Ship. Will you accept the enclosed black dust as a fulfillment of my promise? It was really scraped by my fingers from the broken end of one of the timbers; and if inspected with a microscope will show woody*

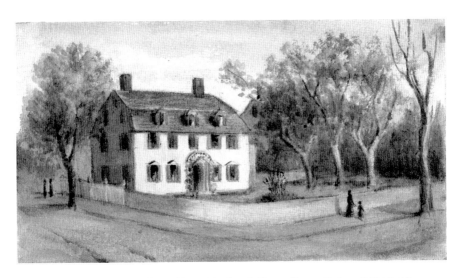

Morrison House (John Paul Jones House) by Sarah Haven Foster. *Portsmouth Public Library, Portsmouth, New Hampshire.*

fibers of the Viking age. Regretting that I could not procure for you a piece large enough to make a paper cutter, I remain, with much love to your aunt Caroline, yours faithfully, Sarah H. Foster.

She never lost her love for the past. She continued to paint and travel until late in life. She and her sister never married. Though little is known of her private life—her loves or losses, her hopes and dreams—her work remains. Her paintings and writing allow modern tourists to visit the past.

What is unique about Portsmouth is that so much of what Sarah showed us is still visible today. Progress has changed Portsmouth, and many of our interpretations of history have changed. Each generation finds different meaning from the past. Sarah was drawn to stories of Portsmouth's wealthy colonial merchants, shipbuilders and revolutionaries. Our modern interpretation is more inclusive and diverse.

Today, our Portsmouth includes fascinating stories of women, immigrants and African Americans. The scenes and houses that Sarah described have been carefully restored and preserved. Portsmouth's growing success as a heritage destination attracts new visitors because of its unique mix of ancient houses, modern dining and vibrant arts community. As a result, guidebook in hand, a modern visitor may explore the world she knew and loved. Sarah's vision thrives.

Ellen and Helen Gerrish, 1835–1940:
Forgotten Sailors

BY KATE FORD LAIRD

In the nineteenth century, Portsmouth was one of the busier cities in the country, with shipbuilding and sea captains at the heart of its prosperity. In the twenty-first century, all that remains of that world are the brick warehouses—now condos and boutiques—and stately homes with bronze plaques describing the captains who once lived there.

Although Portsmouth history remembers its sea captains and shipbuilders, it remains quiet about the women who went to sea, of which there were quite a few. One of the great myths of the age of sail is that women were left on shore, bad luck in the man's world of merchant shipping. Unless they were remarkable sailors or recorded in official ship logs of vital statistics (usually only if they died or gave birth during the voyage), women at sea are invisible in the historical record. Presumably Portsmouth had its share, and this story of Ellen and Helen Gerrish should be seen as an example rather than a remarkable aberration.

Recent scholarship has eaten away at the legend of women being bad luck at sea and, instead, has turned up stories of pirates and navigators. Several newly published diaries chronicle the lives of women who sailed with their husbands, sometimes for years at a time. Although common sailors often lived transient lives on land, captains generally were successful enough to maintain homes ashore, even if they were gone for years. Nevertheless, many chose to bring their wives with them onboard to share "their lives in peril on the sea."

Shipowners (and often captains who owned a share in their vessels) had the final say on whether women would be allowed, but for some, having wives

aboard was clearly an advantage. Josiah Creesy, the commander of one of the most famous ships of all, the clipper *Flying Cloud*, relied completely on his wife Eleanor for navigation. Her skill with celestial calculations, dead reckoning and meteorological patterns was a critical part in *Flying Cloud*'s recordbreaking runs on the brutal passage from New York to San Francisco around Cape Horn at the tip of South America.

In 1854, the husband-and-wife team set a record that wouldn't be broken for 135 years and never by a cargo-carrying square rigger. Navigation was a skill practiced by many seagoing women. In some ways, it was a remarkable departure from the mores of the time. Trigonometry was beyond the educational expectations of most nineteenth-century women, and such responsibility was almost unheard of on land. The slightest mistake, particularly in the storm-ridden waters off Cape Horn, could kill the entire crew, yet Eleanor Creesy wasn't the only woman to take on such a role.

Sometimes, the wives even took command. Mary Ann Patton was nineteen and pregnant when her captain husband went into a tubercular coma as *Neptune's Car* sailed into the Southern Ocean. Although the first mate tried to mutiny, the crew stood behind Mary Ann, who led them through 50 long days bashing against the wind around Cape Horn, reaching San Francisco in 134 days, the second-fastest passage in 1856.

The nineteenth century's new women's movements were not insensitive to these feats of intellect and physical courage. But usually, the seafaring women didn't see themselves as revolutionaries, interpreting their roles instead as a natural extension of the Victorian domestic sphere they would have had on land. Mary Ann Patton felt she was only helping her husband and refused to have anything to do with the Boston feminist groups, although the birth of her son, followed two weeks later by her husband's death and the discovery that she, too, had tuberculosis, may have had something to do with her reticence.

Portsmouth, like Boston and other port cities, may have had several of its daughters go to sea, but few chronicles of their experiences exist. Only one remaining example has come to light and through indirect means.

Lavinia Ellen Pray was born June 11, 1835, in Portsmouth. Her father, Samuel, and her stepbrother were both captains, so the sea was a world she knew well. She appears to have left no diary of her life aboard ship, and if she and her husband hadn't been captured by a Confederate privateer, there would be no record of her adventures and no hint on her gravestone in Proprietor's Burying Ground that she was a Cape Horner.

Ellen, as she was called, was a month shy of twenty-four when she married Edwin Augustus Gerrish in the South Meeting House on May 26, 1859.

Gerrish, at thirty-two, was already a successful captain, but although he was in Portsmouth for the 1860 census, he was too often at sea to be listed in the town register for another eleven years.

Edwin had been born across the Piscataqua on Gerrish Island in Kittery, Maine. At the height of the sailing trade, Portsmouth and Kittery were more closely intertwined than they are now, as both towns drew their livings from the river between them. Edwin came from a long line of captains, which can be traced back to Captain William Gerrish, born in Bristol, England, in 1620. At nineteen, he immigrated to the American colonies, beginning what would become a prominent family name in Portsmouth and Kittery.

The connection with Ellen's family began a dozen years before, when her half sister, Lucy, married Captain Charles H. Gerrish, probably Edwin's brother. Their marriage only lasted seven years, however, for Charles died in New Orleans in 1854.

It appears that Ellen and Edwin set up house with Ellen's widowed mother, Helen Brown Pray, at 13 Deer Street in Portsmouth. Widowed Lucy and an unmarried sister, Julia, may well have lived there too, but only her mother, as head of the household, is listed in the Portsmouth directory for those years.

Their first child was born September 29, 1860, but Albert Edwin only lived for a year and four months, dying January 26, 1862. A daughter, Helen Brown Gerrish, named after Ellen's mother, arrived soon after. None of Ellen and Edwin's children are listed in the Portsmouth baptismal records, but whether they were at sea during those years or the Gerrishes never bothered to document such events is unclear.

From port records, Edwin can be traced crisscrossing the Atlantic in a variety of ships, and it's very possible Ellen and the children accompanied him. As Alan Villiers noted in *The War With Cape Horn*, "It was quite usual for whole New England families to be raised together in the spacious and comfortable quarters of a big, well-founded downeaster."

Spacious, perhaps, but not comfortable for long, at least on the route Ellen sailed with her husband in 1863. The voyage was no trip for a neophyte, which makes it seem likely Ellen had already made a few passages.

The couple traveled to Philadelphia with their young daughter, where Gerrish took command of the Portsmouth-built *Rockingham*. It was a fully rigged ship built in 1857 of white oak, the foundation of the New Hampshire shipbuilding industry.

Although well suited for all the rigors of oceanic travel, the *Rockingham*'s arrival on the shipping scene came too late. The first half of the decade

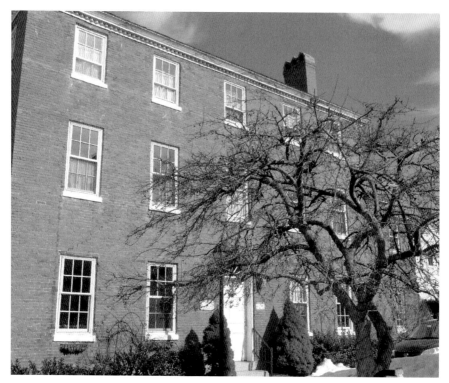

Above: Edwin, Ellen and Brownie Gerrish resided with Ellen's mother, Helen Brown Pray, at 13 Deer Street in Portsmouth. *Photo by John P. Schnitzler.*

Left: Helen Brown "Brownie" Gerrish, dated February 17, 1864. *Portsmouth Athenaeum, Portsmouth, New Hampshire.*

had seen ferocious racing around Cape Horn to San Francisco, where gold rush inflation made huge profits for East Coast merchants. Boats built in the late 1850s, however, had to compete for cargoes against a surplus of ships, deflation in California, train tracks, threatening steamers and, soon, the blockades and privateering of the Civil War.

Men such as Edwin Gerrish had to turn to new cargoes and new customers to survive. With wife and daughter aboard, he sailed out of Philadelphia on April 10, 1863, bound for "hell on earth"—the guano mines of Callao, Peru. But before they could reach Peru, they had to round Cape Horn, fighting the gales of winter in the southern hemisphere.

Including a stop in Panama, it would take the Gerrish family 224 days to reach Peru. By comparison, the bigger, faster *Flying Cloud* had managed New York to San Francisco, nonstop, in a mere 89 days.

What did Ellen Gerrish do for those seven months? Judging from most of the diaries of other sea captains' wives, her chores were very like what they would have been back on Deer Street in Portsmouth: washing, caring for two-year-old Helen, sewing clothes, embroidering. But it's also quite likely she assisted with bookkeeping in port and perhaps learned some celestial navigation.

Taking sights and figuring longitude and latitude was a common practice for wives onboard ship, for while it certainly nudged against the boundaries of the proper women's sphere, it didn't require the physical strength of sail handling or helming, jobs reserved for male sailors. Although there are a few documented cases of eighteenth- and nineteenth-century women hauling sails and working aloft in the rigging, Ellen Gerrish would never have done such things. Going to sea was one thing, and indeed part of her family tradition, but working the ship was out of the question for someone of her background.

To reach Peru on November 20, the *Rockingham* had to round Cape Horn in the early southern hemisphere spring. By now, after a voyage down the east coast of North and South America, Ellen would have been well accustomed to the routine on board ship. Every half hour, bells rang out to indicate the time. Life was measured not in days but in four-hour watches. In all likelihood, Edwin Gerrish would not have stood a watch but would instead have been on call twenty-four hours a day. For a merchant captain looking toward his profits, the more time on deck the better, watching the rig and supervising the crew, many of whom were there against their will.

Ellen Gerrish's life aboard would have been a lonely one. Edwin would have been entirely preoccupied with the ship, and although Ellen might

occasionally help care for injured sailors, she would have little to do with them socially. The men aboard were a rough lot, particularly as trade declined and cargo rates dropped in the early 1860s. It's likely some of them were there because they'd approached the wrong prostitute in port, been lumped on the head and woken up aboard ship, destined for Cape Horn.

After sailing through the heat of the tropics, the temperature would have plummeted as the *Rockingham* headed south of Buenos Aires and the Rio Plata. Because they were heading westward around the Horn and into the prevailing winds, weather systems would surge toward them, reducing life to survival. In twenty-four hours, it would not be uncommon for winds to shift from a relative calm to a screaming seventy-five miles an hour and back again. A hard-driving captain would capitalize on every shift, sending his crew aloft to furl and unfurl sails, hoping to gain another mile of westing.

At the worst of it, Ellen and Helen were probably below, bracing themselves against bulkheads and praying. The oak planking creaked at the best of times, and here, the ship bashed through 40- to 50-foot seas, with waves breaking over the deck. It was a usual thing to lose a few sailors over the side in any Cape Horn passage. All 120 feet of the *Rockingham* crashed to a halt every few minutes as it hit a big wave. With each impact, Ellen and Helen would be thrown against the bulkheads as they listened to the shrieking of the wind through the thin rigging that held up the masts.

A traditional halyard-sweating song, "A Long Time Ago," describes the route:

> *Around Cape Horn where the salty winds blow,*
> *Around Cape Horn through the ice an' the snow.*
> *Around Cape Horn we've got to go,*
> *Around Cape Horn to ol' Callyo.*
> *I whist to the Lord that I'd never been born,*
> *to be all a-ramblin' round Cape Horn.*

Did Ellen wish she'd never been born on the run to Callao? Almost without a doubt. Villiers recalled a certain Mrs. Barker who, while sailing with her captain husband, spent much of her passage through the Southern Ocean with her small children "lashed down together in the large berth in the master's cabin." If Ellen were very lucky, two-year-old Helen would have found it fun and not added her screams to the ceaseless racket of the ship.

With the endless buffeting and noise, there wasn't much room for intellectual diversion. Perhaps Ellen could concentrate enough to think of Portsmouth, its sugar maples gold and crimson in October, the air crisp with

the promise of winter, friends and family and her house on Deer Street. Or perhaps she just listened to the different noises, trying to discern what was happening on deck, as she would have known that a dismasting would likely mean death, grinding against one of the ten thousand rocks and islands spiking up through this frothing sea.

Or did she spend her hours wondering if her husband had washed over the side under the last press of water? Or if the crew had reached its limit and was plotting a mutiny in the fetid fo'c'sle? Certainly, the crew on deck had it worse, with a wind chill of negative twenty degrees Fahrenheit, inadequate clothing, barehanded, perhaps barefoot, frostbitten, exhausted, underfed and the wrath of the Southern Ocean hitting them in gale after gale.

The sailors had a saying, "below 40 South, there is no law; below 50 South, there is no God." In that case, they were all well beyond God's reach now, probably tacking past 60 South, as they struggled against the wind. In the Southern Ocean, the best a square-rigged ship could do was sail about 80 degrees off the wind, which meant to sail one hundred miles over the ground she might have to cover more than six hundred miles through the water.

But at least the crew on deck was desperately busy to take their minds off the danger. Navigation was certainly a way for women to occupy their minds, though it would mean climbing on deck whenever the steel gray skies allowed for a glimpse of the sun or the stars to take a sextant sight. Sometimes the captain or mate might take the actual measurement, leaving the woman in the relative safety and warmth below deck to handle the calculations and plotting.

In the worst case, the *Rockingham* could have taken a few months to round "Cape Stiff," as the sailors called the Horn because it had killed so many. But the conditions are often so stultifying that even a reasonably fast passage of a few weeks would seem endless, and it would have been with great relief that Captain Gerrish finally turned the ship north up the west coast of Chile.

The temperature would remain cold as they rode the Humboldt Current north, and the rocky shores of Chile would still present a threat, but at least Cape Horn was behind them, for a few months anyway.

The *Rockingham* cleared into Callao on November 20, 1863, and after a mere week in port sailed south for the Chinca islands off the coast of Pisco. The guano mines were fifteen miles offshore, twice as far as the Isles of Shoals are from Portsmouth, yet the stink of guano hung over the town of Pisco in the summer air.

The Chinca group boasted mountains of dried seabird droppings, often more than one hundred feet thick, which had to be hacked off with picks and shovels. The *Rockingham* spent nearly three months loading its cargo, which

was about average. Peruvians had used this reeking substance for centuries as fertilizer, but it was only in the 1840s that the English began importing it, followed quickly by the Americans. Huge profits could be made in the guano trade in many parts of the Pacific, but the Peruvian environment produced the best fertilizer of all.

According to Jimmy Skaggs, author of *The Great Guano Rush*: "No nineteenth century job...was as difficult, dangerous, or demeaning as shoveling either feces or phosphates on guano islands. Worst conditions of all were in Peru where workers (many of them literally kidnapped into slavery) routinely resorted to suicide as their only means of escape...The Chincas...were the most dreadful guano islands of them all." Tropical heat, high humidity and yet virtually no rainfall made the Chincas a hell on earth.

Despite what they had suffered at Cape Horn, the sailors' lives were good in comparison with those they saw in the Chincas. As the ship loaded, the air was ever full of the toxic dust, and the high ammonia content caused severe respiratory problems. Down below, the enslaved cargo trimmers could only endure twenty minutes at a time before crawling on deck, often "with nosebleeds or even temporary blindness."

Because Ellen and Helen Gerrish couldn't follow the sailors aloft to their retreat from the stench, it seems likely they remained behind in Callao for the three months the *Rockingham* loaded its cargo. The year before, seventy to eighty American ships had loaded guano at the Chincas, but Confederate privateers meant few ships were willing to fly the stars and stripes of the Union flag.

Raphael Semmes, captain of the privateer *Alabama*, noted in his log that a French ship in April earlier that year reported not a single American ship was to be found at the Chinca islands. Since the French captain certainly overlapped with the *Rockingham*'s stopover in Peru, it's possible he was protecting the Gerrishes with his assertion. On the other hand, the French captain may have simply assumed they were English. Edwin Gerrish had contracted with British concerns for his cargo, and doubtless the Gerrishes would have socialized with British captains and their wives, especially as there were few Americans making the run that year.

From the diaries of other women, we know there was an active social life between the top personnel of ships in port, and it was not uncommon for wives to take up lodgings on their own while their husbands contended with cargoes and merchants.

On February 24, 1864, they went to sea again, this time bucking the frigid Humboldt Current and its accompanying winds as they headed south to

Captain Edwin Gerrish, seated.
Portsmouth Athenaeum, Portsmouth,
New Hampshire.

the Horn. Once they reached the tip of South America, however, they were sailing with the wind and current, which made conditions aboard slightly better. Instead of fighting the huge seas head-on, they would be surfing down them. It was still cold and dangerous, but they were, at least, in the last days of the southern summer.

From the Horn, their course was straight up the Atlantic to Ireland. Apart from the doldrums, a band of light wind and sudden squalls north of the equator, it should have been plain sailing.

Back at home, Portsmouth was alive with the news of the Civil War. Ellen and her husband might have had word or letters from other ships, and they might have been able to communicate with a southbound ship for more current reports, but as they headed up the coast of Brazil, the muddy winter battlefields of the war were remote from their world of stifling, hot below-decks and scorching sun above.

Over the horizon, however, the Civil War was about to become an immediate and terrifying reality, in the form of Captain Raphael Semmes and his privateer, the *Alabama*.

The 220-foot, eight-gun bark was returning from a two-year cruise to Borneo, having taken sixty-one ships bearing Union colors along the way. The *Alabama* had begun life in Liverpool, England, as "290," built with a tenuous adherence to British neutrality. Its guns and new name were added under subterfuge in the Azores, and Raphael Semmes took command of a crew of Confederates and a number of British sailors simply looking for adventure.

Gerrish tried to outrun Semmes, holding his own throughout the night, but at dawn he yielded, protesting vainly that his cargo was owned by neutral British concerns. Although it was normal procedure for privateers to bond such cargoes, Semmes took the crew and family aboard and proceeded to use the *Rockingham* for target practice.

Ellen and Helen soon found themselves crammed in the leaking wardroom of the *Alabama*, their prison for the forty-nine days it would take to reach Cherbourg, France. Gerrish's first mate, Robert Longshaw of Savannah, signed on with the Confederates, but the rest of his crew remained loyal.

Semmes's crew and his ship were tired. He tried to offload his prisoners on another ship but without success. Meanwhile, his crew fussed over little Helen, making her toys, including a doll's folding camp stool and chest of drawers, which are now at the Virginia Historical Society library.

Alabama's assistant surgeon, Dr. David Llewelyn, presented little Helen with a picture on which he'd inscribed, "Brownie Gerrish last prize of this pirate from D.H. Llewelyn, CS Pirate *Alabama*, May 21, 1864." His words proved prophetic, for the twenty-seven-year-old doctor would die just a month later in the *Alabama*'s final battle.

On June 11, they reached Cherbourg, the ship leaking and worn and its skipper recovering from a fever. Offshore lurked the *Kearsarge*, a Portsmouth-built seven-gunner, under the command of a North Carolinian, John Winslow, who remained loyal to the Union.

Once on French soil, Edwin Gerrish tried to join the *Kearsarge* and avenge the loss of his ship, but navy regulations prohibited merchant sailors from fighting. So Edwin contented himself with providing Winslow with all he knew of the *Alabama*'s capabilities and watched the ensuing battle between the two ships from the hill above with a crowd of French tourists.

At ten-thirty in the morning of June 19, the *Alabama* and the *Kearsarge* began their battle, making a corkscrew course as they fired round after round at each other.

Working from a variety of contemporary sources, historian William Marvel described the end of the *Alabama* two hours later: "The prow pointed

U.S. steamship *Kearsarge* and Confederate steamer *Alabama* nine miles off Cherbourg, France, by Thomas P. Moses, Portsmouth, July 1870. *Mariner's Museum, Newport News, Virginia.*

skyward as the stern filled rapidly. The mainmast snapped where it had been chewed away by a shot, and in an instant the fouled bottom with its peeling copper flashed in the midday sun. Then—by the count of three...—the *Alabama* slipped stern-first beneath the English Channel, five miles off the Cherbourg breakwater in forty fathoms."

Captain Semmes survived the sinking, as did the *Rockingham*'s erstwhile first mate, Robert Longshaw, among others.

The Gerrish family then returned to Portsmouth and Edwin soon to sea. The remainder of 1864 continued to be a hard year for Ellen's family. Her brother Charles H. Pray drowned off Cape Horn on the ship *Prima Donna*, and her half sister, Lucy, died in Portsmouth.

It's unknown whether Ellen went to sea again after sailing back to Portsmouth, but after the birth of her third child, Charles Wentworth Gerrish, on October 10, 1865, she certainly remained at home for a number of her husband's voyages, raising Helen and Charles at her mother's home on Deer Street.

Edwin continued sailing. He made dozens of trips around the Horn and was remembered in the *Portsmouth Herald* as "a portly, commanding man, a thorough navigator, a strict disciplinarian on board ship, and one whose sympathies were easily touched. He was one of the most genial and whole hearted of men, and made a proud record on the sea."

He was frequently part owner of the ships he sailed, often joining with other Portsmouth men in the purchase and usually looking to Piscataqua-built ships for his investments. In 1878, he took command of the *Paul Jones*, "the last of the hundreds of three-masted, square-rigged sailing vessels launched on the Piscataqua or its tributaries."

Edwin was badly injured in an Indian Ocean storm—bad weather isn't restricted to Cape Horn—and the round trip to Manila took fourteen and a half months. Over the next few years, he was rarely in Portsmouth, and in 1882, Ellen and his children traveled to New York to say goodbye before he and the *Paul Jones* sailed for Java. Helen was about twenty and her brother, Charles, sixteen. While there, Charles caught scarlet fever and died in the city. Ellen returned with his remains and buried him next to baby Albert Edwin in Proprietor's Burying Ground on South Street. Edwin cleared customs two weeks later, off on a voyage of at least a year. Ellen and Helen remained at Deer Street with Ellen's mother (also Helen), who was still going strong at seventy-four.

Edwin's health was poor at this time, and two years later, he took an unplanned respite from the sea. But by the time Ellen died on December 16, 1891, "after a long illness," he was back in command again, this time collecting a cargo of nitrates (used in explosives) in Chile. It would take another trip around the Horn and four more months before he would hear of his wife's death.

Ellen's mother had died earlier in the year, in April, and combined with Edwin's poor health, it's tempting to speculate that the family suffered from something contagious and common like tuberculosis. There's no documentation, however, of the nature of any of their illnesses, although Edwin did suffer a stroke in Manila three years later.

By 1897, Edwin was confined to a hospital in Boston. In the *Island and Harbor Echo*, he's described as having "circumnavigated the globe a score or more times [and] never lost a ship except by capture…Gerrish is as well known in the commercial world of London, Liverpool, Hong Kong, Manila, Calcutta, San Francisco, as he is in Boston or Portsmouth, and when the name Capt. Edwin A. Gerrish is spoken it is synonymous with integrity, fidelity, and big heartedness."

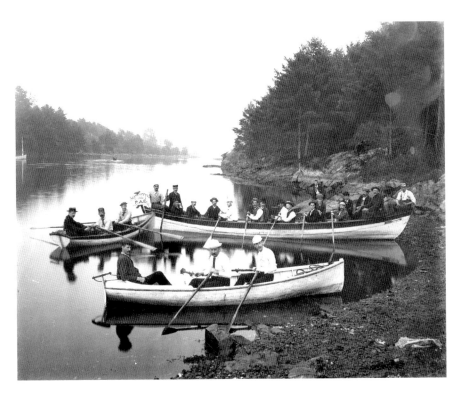

An outing of the Mascotte Boat Club, a division of the Portsmouth Athletic Club on a visit to Chauncey Creek, lands boats at Gerrish Island. *Patch Collection, Strawbery Banke museum, Portsmouth, New Hampshire.*

In 1905, Edwin died in Sailor's Snug Harbor in New York. His daughter Helen still resided at 13 Deer Street and worked as a nurse. "Brownie" Gerrish never married and stayed close to home in Portsmouth, moving from Deer Street to rented rooms on Chapel and, later, State Street, where she lived until May 18, 1940.

The world had transformed during her lifetime. The great sailing ships of her father's age became coal barges and dock floats if they hadn't simply sunk quietly after years of bashing through the Southern Ocean. The economic boom years of the gold rush and guano trade slid away, and merchant sailors now sailed in flotillas of steel steamships. Ships and captains were still threatened by war, but in World War II, danger would lurk under the water and in the air as well as from the guns of another ship.

Automobiles had come to Portsmouth, and the shipwrights of the Piscataqua River basin were replaced by riveters in the Portsmouth Naval Shipyard.

But even now, years after Helen Gerrish's death, big ships must wait offshore for the slack tide before they dare motor into the Piscataqua to deliver coal for our electricity and salt for our icy highways and pick up rusty iron and high-tech cable.

And the first landmark they see, as long as it's not a foggy summer's day, is the double blink of the Whaleback Lighthouse off Gerrish Island in Kittery.

Mary Baker and Alta Roberts, 1855–1940: Madams of Portsmouth's Red-Light District

BY KIMBERLY CRISP

S trolling among the pristine gardens, immaculately restored antique homes and gracious public park of Portsmouth's Marcy Street, it is difficult to envision that at the turn of the twentieth century, it was the infamous hub of a world-renowned red-light district. Between 1897 and 1912, more than a dozen houses of ill repute flourished on this thoroughfare that was then known as Water Street.

Of all the brothel operators, Mary Amazeen Baker was the most notorious. Celebrated for her diamond-studded front teeth, her gaudy furs and her brilliant henna beehive-styled wigs, Mary and her husband, Allen, opened the Gloucester House Saloon at the corner of Water and State Streets in 1897.

Alta Roberts, who also launched her Water Street saloon in 1897, was equally intriguing. Known as the Black Mystery of Portsmouth, Roberts always donned black and rarely left her home at 14–16 Water Street, where she operated her brothel at the Roberts House Saloon. Despite their diverse personalities, both women were instinctively clever businesswomen, and along with several other entrepreneurs, they recognized the inherent potential for the flesh trade at the Water Street locale.

Situated at the south end of Portsmouth along the banks of the Piscataqua River, Water Street had been the region's commercial center for the timber export and shipbuilding business during the colonial era. However, economic growth began to shift inland during the first half of the nineteenth century as manufacturing ventures and railroads developed in other areas of the city

and state. Wharves along Water Street that were once utilized for the export of timber and other goods became depots for coal imported to fuel inland factories.

The character of neighborhood businesses changed as well, reflecting the emerging transient customer base. Saloons replaced grocers and artisan shops on Water Street as business shifted to serve the growing foot traffic of visiting mariners and sailors stationed on ships docked directly across the river at the Portsmouth Naval Shipyard in Kittery, Maine. The transition of its commercial character, along with its proximity to the Piscataqua River, made Water Street a prime location for the burgeoning vice trade.

Although prostitution may be found in many different towns and cities, it has always been particularly prevalent in maritime areas serving transient populations. Legendary red-light districts such as the Barbary Coast in San Francisco, Storyville in New Orleans and the Tenderloin district in New York City bear testament to the success the profession has found in port cities.

On a smaller scale, the seaport town of Portsmouth was no exception. The red-light district evolved in the 1890s on Water Street as marine traffic that had flourished throughout the nineteenth century mushroomed in the wake of the Spanish-American War. Naval strength in the United States was at an all-time high, and hundreds of military ships visited the Portsmouth Naval Shipyard. Warships such as the *Nevada*, the *Kentucky* and the *New Hampshire*, with complements of 500 to 1,000 men, frequented the port, and it was not uncommon for liberty parties of up to 1,500 sailors to cross the river to Portsmouth.

Along with the steady influx of warships were the barges, sloops and scows delivering bricks, sand, wood, coal and other supplies to the shipyard. These vessels were usually manned with complements of ten to thirty men and were often docked at the navy yard for several days while unloading cargo. Large merchant vessels frequented Portsmouth as well, and many anchored at the wharves off Water Street. This traffic generated a large contingent of transient males who came to Portsmouth seeking entertainment.

William Dunn opened his Union House Saloon in 1890 at 15 Water Street, and in 1895, Mattie Bond purchased police officer James Kehoe's property at number 12 and started the Clifton House. Both Bond and Dunn reportedly operated brothels along with their saloons, the saloon providing the convenient and legitimate public front for the illicit business of prostitution.

Also in 1890, Charles E. Gray established his business offshore of Water Street on Four Tree Island. Gray's establishment, the Four Tree Island Museum and Emporium, had an especially notorious reputation. Water

Street resident Gertrude Moulton recalled Four Tree Island as a "leper colony," alluding to local opinion that deemed it the lowest of lowly places.

Portsmouth native John McKenna revealed the source of the establishment's name: "The building was decorated with things sailors had brought back from overseas, stuffed alligators, things like that. That's why he called it a museum. There was a stuffed cow in the bar, and you would pull the udders and booze would come out."

Despite the refined name, the Four Tree Island Museum and Emporium attracted a rough clientele who sought out cockfights and gambling, along with liquor and prostitutes. Portsmouth native James Cox explained how customers were transported to the island: "To get to Four Tree Island, sailors would have to pay a boatman, who had a monopoly on the business, fifty cents to row them out to the island, and five dollars to bring them back. Of course, they didn't find out about the cost of the return until later on when they were well-oiled."

Reportedly, vice flourished on Four Tree Island because Portsmouth city marshal Thomas Entwistle claimed his police department did not have jurisdiction over the island. The debauchery on Four Tree Island was brought to a standstill in 1902. A fire destroyed the museum while city firefighters, who were unable to reach the island, stood helpless on the shore.

The success of Four Tree Island and the other Water Street saloons served as a template for other speculators who wanted to try their luck in the vice trade. Jane Cook, who is a descendant of the Water Street madam Mary Baker, said: "I was told Mary Baker had the first house on Water Street in the late 1890s. She opened the house because she saw a big opportunity to make lots of money."

Mary Amazeen Baker and her husband, Allen Baker, opened the Gloucester House Saloon in 1897, directly across the street from Charles Walker's Coal Company, a prime spot no doubt because Walker operated the ferry that transported the sailors across the Piscataqua to and from the navy yard. The Bakers rented the Gloucester House property from famed Portsmouth brewery and hotel owner Frank Jones; Mary Baker later purchased the property from Jones's estate after he died in 1902.

Mary was born in New Castle, New Hampshire, on June 19, 1859. Her father was also born in New Hampshire, and her mother was a native of Nova Scotia. Not much is known about Mary's early years. Jane Cook recalls some family background: "The Amazeens came here in the late 1500s, and they lived out at the Isles of Shoals. They were pirates and they came from Dutch, Greek, Italian and Portuguese descent because they all intermarried out at sea."

Mary and Allen Baker's Gloucester House Saloon on the corner of Marcy and State Streets in 1897, one of several bordellos on Marcy Street's red-light district. *Patch Collection, Strawbery Banke museum, Portsmouth, New Hampshire.*

Colleen O'Leary and Polly Goldman knew Mary Baker when they were children during the 1920s and remember her distinct appearance: "She had diamonds in her two front teeth. She had a passion for jewelry, and she always wore a beautiful brooch at her neck. Mrs. Baker was always elegantly dressed, and when she walked downtown with her cane and her fur muffs, she looked like somebody. She wore a brilliant henna wig that was styled in a beehive, which made her look almost six feet tall."

In 1889, Mary married Allen Baker of Massachusetts, but where they spent the first years of their marriage is unknown. The Bakers were probably in Portsmouth in the 1890s just before opening the Gloucester House Saloon.

Along with her unique appearance, Mary Baker's business establishment was keenly recollected by neighbors, such as Gertrude Moulton, who elaborated on the Gloucester House interior: "You never saw anything like it. There were mirrors on the ceilings and the rooms had little cubbyholes, and I didn't know it at the time, but that's where the girls were. The house

had a great big beautiful ballroom with a great big chandelier. There were red velvet curtains and paintings of bosomy nude women on the walls. It was really quite grand."

The Bakers also operated an ice cream shop that was connected to the Gloucester House. Jane Cook stated why: "I was told that Allen Baker did not like the prostitution business, so he put the ice cream parlor out front. But Mary still had the other business going on at the same time."

Many of the neighborhood children bought ice cream cones at the shop, and Polly Goldman and Colleen O'Leary remember being served by the Bakers: "He was very nice. When you went in and got an ice cream, you would get extra because he packed it in with a tablespoon. But if it was Mary, you got just exactly what you asked for. She was a businesswoman, you know. And when she waited on you, she was always dressed in her elegant clothes and jewelry. She was very much the lady all the time."

Madam Alta Roberts also opened shop on Water Street in 1897. In October, she purchased the saloon at numbers 14 and 16 from Timothy Buckley. The daughter of a Civil War hero and a direct descendant of Revolutionary War Patriot Joseph Warren, Alta Warren Roberts was born in Limerick, Maine, in 1855. She married Frank Roberts, and they worked together in vaudeville during the 1880s. She lost a son in childbirth and was unable to have any more children. After her husband died, she lived with her sister Sarah Dawson in Ware, Massachusetts, where she worked in a textile mill. She moved to Portsmouth in 1897, perhaps on the suggestion of her sister Phoebe who lived there with her husband, William, a Water Street boat builder.

Known as the Black Mystery of Water Street because she always dressed in black (perhaps in deference to her late husband) and rarely left her house, those who remember Roberts frequently described her as a "tough broad, but pleasant." Tall and imposing, she had long red hair, and like her colleague Mary Baker, she invested substantial money in her mouth. Family member Ellen Clark explained: "Great Aunt Alta wore gold casings over her teeth. She was following an Oriental custom where gold in your mouth was considered a sign of wealth, privilege and beauty. It was also a way of always having money with you if worst came to worst."

Alta was also reputed for her kindness and generosity: "Uncle Ernest, who worked as a towel boy in Great-Aunt Alta's whorehouse, told me that when someone came to her door and needed help, she never turned them away. Two floors of her house were used for business, and the third floor was where she put people who had no place to stay. She helped feed a lot of

Alta Roberts, seventy-eight, at her Marcy Street home in 1933. *Courtesy Kimberly Crisp.*

hungry families, and she put a few Portsmouth boys through college. When the golden chalice at St. John's Episcopal Church was stolen, she bought the church a new chalice and helped recover the stolen one."

She ran her business from a three-story tenement duplex. Number 14 Water Street housed the saloon and the bordello while the other side of the building, number 16, served as her living quarters. Her niece, Ellen Clark, detailed the interior: "The saloon had a dance hall where a three-piece band played. In the daytime, there were paintings of pretty landscapes on the wall, and then in the evening, she would press a button, and paintings depicting voluptuous nudes would replace the landscapes. Her home was very beautiful. She had an elegant parlor where she would interview prospective clients, and if they were okay, they would be escorted over to the brothel."

Like her associate Mary Baker, whom she referred to as "her friend from college," Roberts had a very successful business. Unlike Baker, however,

her success was probably due to her pragmatic nature rather than a flair for flamboyance.

Along with Alta Roberts and Mary Baker, there were several other Water Street entrepreneurs who made their money peddling vice. Charles Asay, a barber, moved into 10 Water Street in 1898. Asay kept a couple of prostitutes on his second floor and eventually married one named Cora. Mattie Bond operated the Clifton House at 4 Water Street from 1902 to 1908. Harry Bullard worked as a clerk in the Clifton until it closed and then opened a saloon and bordello called the Home with his wife, Ada, at 37 Water Street in 1909. William Dunn ran saloons on Sagamore Avenue in 1899 and Granite State Avenue in 1901 before relocating to 15 Water Street in 1903. "Big Etta" DeForrest and her husband, George, were latecomers to the street, opening at number 62 in 1910. Charles "Cappy" Stewart got into the business in 1904 by marrying his landlady and employer, Mary Skinner, who operated the Esplanade at 51 Water Street.

Like Mary Baker and Alta Roberts, Cappy Stewart was one of the more successful bordello operators on Water Street. Born in Scotland in 1870, Stewart came to the United States in 1881 with his English parents. He opened his first business in 1890, the Manhattan Café, in the center of town at 27 Fleet Street. Cappy gained his initial experience in the flesh trade by renting rooms hourly to couples in the house next to his café. Stewart sold the café in 1898 and worked as a laborer until 1900, when he became a boarder and bartender at Mary Skinner's saloon and bordello at 51 Water Street. He married Mary in 1904 and managed the business until the city closed down the red-light district in 1912.

Many neighbors and descendants recalled the prostitutes who worked in the houses. As a young girl, Polly Goldman regarded the women as conspicuous characters: "I always used to think, 'Look how dressed-up those girls are,' and their shoes…they wore baby-doll pumps with round toes and spike heels. They would wait at the top of the street where the sailors would come in off the ferry."

Colleen O'Leary shared an account of how attractive many of the women were: "My mother said that Mary Baker had such beautiful girls in her house. They were so elegant and they were always dressed in their best clothes. Whenever Mary Baker got a new girl at her house, my mother said that the girl would get all dressed up and Mary would ride her through the main street uptown in an open carriage so all the men and merchants could see the new girl."

Apparently, promenading the prostitutes through the city was also a popular form of advertising for other bordello owners. Cappy Stewart's

friend Thomas Haak recalled: "One thing I remember Cappy saying was that he changed girls every two weeks. He'd take the girls who had been there two weeks up to the railroad station in carriages and drop them off. The train would drop off the new girls, and they would get in the carriages and parade all around the city of Portsmouth. Everybody would say 'Oh, Cappy Stewart's got some new girls in!'"

The reputation of the red-light district attracted scores of young women to the city seeking employment in the whorehouses. For many prostitutes, working in a house was preferable to street walking because it was safer and offered more comfortable accommodations for the transaction of sex. Subsequently, the Water Street brothel owners could be very selective in hiring the most attractive women.

Because they serviced such a transient clientele, the madams were concerned about checking the spread of venereal diseases. Mary Baker and Alta Roberts shared a reputation for operating "clean" houses. Roberts's niece, Ellen Clark, said: "Great-Aunt Alta was reputed to have the cleanest house in town. Each girl had a ticket, and every month, the girl would go to the doctor, and he would punch her ticket as proof that she was clean. The girl would hang the ticket on the wall in her room so the customers could see it."

John McKenna also noted: "Mary Baker ran a very tight ship. Her place was supposedly very clean. She had her girls examined every two weeks by a local doctor who would come to the house."

It is difficult to estimate the number of venereal disease cases in Portsmouth during this era, as none were listed in any of the city annual reports. Despite an 1883 state law that required detailed disease statistics be reported to the state, cases of syphilis and gonorrhea were not listed in the city report until 1918.

Although the numerous sailors who came through the port constituted a large share of the customer base, the houses cultivated an impressive local following. Ellen Clark asserted: "Most of the upper echelons of Portsmouth were Aunt Alta's customers. Every judge, lawyer and clergyman in town frequented her house. Judge William Marvin was a customer, and police officer George Ducker, who later became the city marshal, had a special girl at her place."

Madam Mary Baker also claimed many of the local gentry as her clients. John McKenna maintained "she was in cahoots with the city marshal, Thomas Entwistle, and entertained him regularly." Additionally, Jane Cook declared Baker's association with a prominent local businessman and politician: "Mary

Baker was a very good friend of Frank Jones, and her ladies frequented his hotel, the Rockingham, on State Street. I was told that Mr. Jones had beautiful frescoes painted on the ceilings in the rooms so her ladies would have beautiful pictures to look at while they were entertaining his guests."

The local elite and city officials were not the bulk of the Water Street customer base, but they played an important role in perpetuating the existence of the red-light district by colluding with the bordello operators.

The ladies of Water Street were also rumored to have beguiled more than a few men of international importance. John Clark remembered: "Uncle Ernest told me that many European diplomats used to come through Portsmouth on their way to Washington, D.C. Apparently, the port was one of the closest to Europe, so they would disembark in Portsmouth and then take the train to Washington, D.C. Before catching the train, many of them would make a stopover at the houses on Water Street. Uncle Ernest would joke that the girls at Aunt Alta's house knew more about world affairs than the men down in Washington, D.C."

Portsmouth also served as a watering hole for many of the elite who were traveling through to Bar Harbor, Maine. Sarah Clark recalled: "Uncle Ernest said that J.P. Morgan and other millionaires would stop in Portsmouth on their way to Bar Harbor. They would bring the yachts up and moor them in the harbor. He told me of how he used to row Aunt Alta's sister, Lydia, out to the yachts. Lydia was a famous psychic known as Madame Zola. She had a parlor at York Beach in the summer, and during the winter, she would follow her clientele to Greenwich, Connecticut, and Palm Beach, Florida. Anyway, Ernest would row her out to the yachts to read palms, and when they returned to shore, she would have $4,000 or $5,000 in a carpetbag."

While many of those who patronized Water Street came from different areas of the country and the world, an assessment of the 1900 and 1910 federal censuses suggests most of the working girls listed as borders at the different establishments came from within a one-hundred-mile radius of Portsmouth. Although the bordellos on Water Street had a worldwide reputation, and it was fairly obvious to the locals what was going on, the owners were less than honest with federal enumerators about the nature of their business. Therefore, Alta Roberts, Mary Baker and other brothel operators were listed on the federal census as lodging house owners; it may be assumed the hordes of twenty-one-year-old women living with them were not really waitresses, chambermaids, seamstresses, cooks and laundresses.

Arrest logs disclose who was and, more importantly, who was not arrested for disorderly house violations. Most Water Street bordello operators were

This studio photo, taken in 1900, shows Alta Roberts with her two nieces and two gentlemen in a car. *Back row, left to right*: Alta's niece Ida McGinnis, niece Leona Hayward and Alta Roberts. Front left is Ida's husband, William McGinnis. The man in the bowler hat is unidentified. *Courtesy Kimberly Crisp.*

arrested once between 1897 and 1910. Alta Roberts was arrested once and fined ten dollars for "violating city ordinance," and Cappy Stewart was arrested once and fined sixty dollars for "keeping malt and spirituous liquors."

Mary Baker was arrested once for trying to recruit minors for prostitution and once for having a disorderly house. Baker was ordered by the court to leave the city, which of course she did not do. Her husband, Allen Baker, was arrested once for "violation of license" but did not have to pay a fine. Mattie Bond was arrested twice for keeping a house of ill fame and fined a total of $25, and Harry Bullard was arrested once for selling spirituous liquors and fined $150 and once for larceny but not fined.

As the evidence implies, either Keystone-style Kops were in charge at police headquarters or the Water Street bordellos were operating without fear of the law. As in many cities across the United States, it seems a confederacy of Portsmouth politicians, police officers, judges, attorneys and landlords conspired with vice merchants to circumvent regulations and profit from an illicit trade.

Water Street operators owned the property on which their businesses were located. By 1902, Mary Baker, Charles Asay, Harry Bullard, Mattie Bond and William Dunn all owned their buildings, while Alta Roberts and Cappy Stewart owned several other parcels in addition to their business real estate. Most bordello operators in other cities did not own the buildings where they carried on their business because they were often forced to relocate several times each year. The impressive rate of property ownership among the Water Street operators may be a reflection of both their success and their well-established positions with local officials.

The ideal riverfront location, the constant stream of sailors and other patrons and the complicity of city officials undoubtedly contributed to the success of the Water Street bordellos. The combination of these factors enabled the red-light district to thrive on Water Street for fifteen years. Soon, however, the influence of progressivism and the resulting shifts in politics and economics would be felt in Portsmouth as local reformers worked toward the eventual closing of the district.

Susan Ricker Knox, 1874–1959:
Famed and Forgotten Artist

BY JANE D. KAUFMANN

In the 1923 Portsmouth Tercentenary parade, "Famous Sons and Daughters" were represented by costumed role players. Susan Ricker Knox, however, appeared in this category as herself.

She was, at this time, a successful portrait painter and, in addition, was receiving a great deal of favorable publicity for her portrayals of immigrants at Ellis Island. "Miss Knox Gains Fame As Painter" read a caption to an article in the *Portsmouth Herald*; her native city was very proud of her.

Knox had a long, successful and prolific career, spanning more than forty years, with her work shown from the East to the West Coast. An article in the *Boston Sunday Post* of September 10, 1933, is captioned "Susan Ricker Knox, Painter of Portraits All the Way Across the Continent."

After her death in 1959, unfortunately, all this was forgotten, and she slipped into obscurity. An exhibit entitled "Susan Ricker Knox, Portsmouth and Beyond" held at the Portsmouth Athenaeum in the summer of 1998 served as a means to rescue her from oblivion. Although none of Knox's journals, daybooks or correspondences have surfaced, her voice emerges in opinions and quotes gleaned from magazine and newspaper articles, of which there are many, and from interviews with the few people left who remember her.

Knox was a friend and contemporary of the painter Gladys Ames Brannigan, whose painting of Portsmouth from New Castle is in the collection of the Portsmouth Public Library. Knox and Brannigan had a mutual friend in the Portsmouth painter Mary Aubin Harris, who saved clippings about Knox's shows, some of which were annotated by Knox herself.

Born Susie Ricker Knox in Portsmouth on January 26, 1874, she died on June 11, 1959, in Concord, New Hampshire, where she had been living with her nephew. She was the daughter of John H. Knox, the first clerk to the commandant of the Portsmouth Naval Shipyard, and Abbie A. Gotham Knox. The family lived at 93 Union Street in Portsmouth and attended Christ Episcopal Church.

Educated in Portsmouth's public schools, Knox attended art school at Drexel Institute in Philadelphia and later studied at the Cooper Union in New York. From there, she made study trips to Spain, Italy, Paris and London.

Her teachers were Howard Pyle, Douglas Volk and Clifford Grayson. Although her early work is signed "Knox" or "S. Knox," as her career progressed, "Susie" became the more dignified "Susan." She never married and devoted her life to her career.

At first, she became known along the Maine coast and in Boston for a unique form of silhouettes, which were not cut out but drawn in pen and ink.

In 1906, she built Hillside Studio in York Harbor, Maine, and this was her summer studio for many years until light-blocking tree growth at that address instigated a move to Ogunquit. Boston was her home for a short time, but by 1911, the young artist was living in New York City, where her address was listed as a studio at Carnegie Hall. Later, she had an apartment and studio at the National Arts Club.

A successful portrait artist in 1913 New York with a wealthy clientele, Knox was famous enough to rate an illustrated article about her work in the June issue of *International Studio* magazine. The writer stated Knox's "sympathy with her sitters and keen appreciations of human nature are the keynotes of her success."

Although she had many adult sitters, she became particularly known for her depictions of children. Several of these were shown in the Portsmouth Athenaeum exhibit, among them *The Japanese Tea Party*, a bright and summery depiction of two little girls outside beneath swinging Japanese lanterns, much in the manner of John Singer Sargent; *Little Miss Coxie Green*, a bright-eyed, rosy-cheeked little St. Louis girl, the style of which is reminiscent of the child portraits of Robert Henri; and a charming portrait of Portsmouth resident Martha Fuller Clark, done when she was four.

A pivotal experience occurred in the painter's life when she attended an entertainment given by Metropolitan Opera artists for immigrants in the Detention Room at Ellis Island. While portrait work continued to be her mainstay, this encounter later changed the direction of her career. The

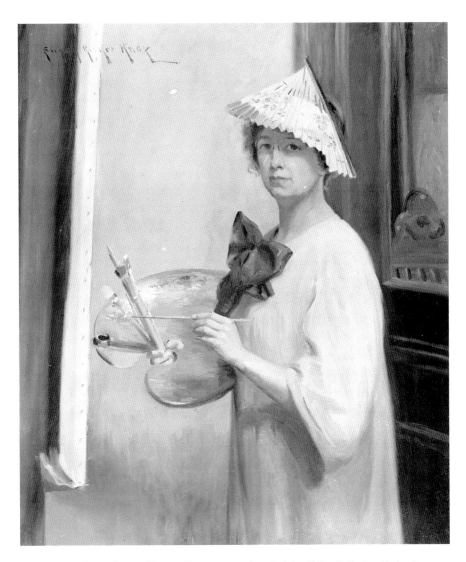

Self-portrait, Susan Ricker Knox, oil on canvas. *Peter A. Juley & Son Collection, National Museum of American Art, Smithsonian Institution.*

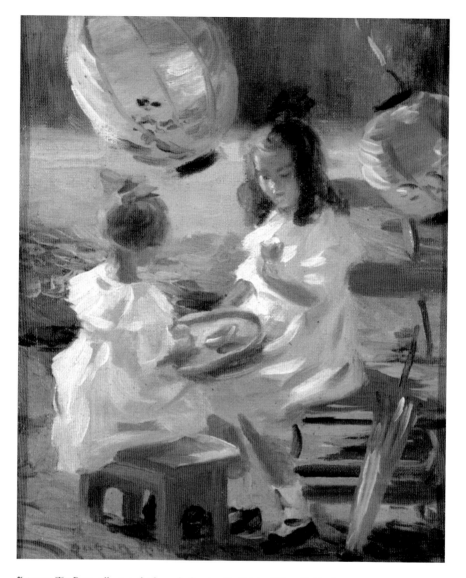

Japanese Tea Party, oil on artist board. *Courtesy the Estate of Jane D. Kaufmann.*

immigrants at Ellis Island awakened an interest in "ethnic types" and led her to the Southwest and Mexico in the late 1920s and 1930s to paint Native Americans and Mexicans.

She was particularly fascinated by what she saw at Ellis Island—the crowd of people of all ages, the different races, the color of the ethnic

dress. She is quoted as saying: "To me, it was the most thrilling thing that had happened in years; never before had anything stirred and stimulated me so, from the standpoint of subject matter for work. Never was there so rich a source of material."

She returned to Ellis Island every day for ninety days and produced thirty-two paintings of ethnic groups. This was a completely new experience for an artist who had always worked in a studio with no more than three figures at a time, but she accepted the challenge.

Knox painted the immigrants at Ellis Island with great sympathy and understanding. She caught the atmosphere of the crowded rooms, the anxiety of the immigrants waiting there—many in the grimy clothing they had worn on the passage over in steerage—and she made no attempt to glamorize her subjects.

She later said: "I felt it within me to show these types in paint. I wanted to show the melting pot as I saw it, with its starkness, its grimness, its stern reality…these people huddled together almost like dumb animals, and I saw in these faces the hope, the fear, the weariness, the wonder that they expressed."

Immigration had increased tremendously since the end of World War I. In 1920, 430,000 immigrants entered the United States. In 1921, the number increased to more than 800,000.

The Ellis Island paintings became well known and were widely exhibited. They were displayed at the Capitol in Washington during the debate on the first immigration bill and were said to have eased the terms of a quota bill, which limited not only the numbers but also the proportion of immigrants from southern and eastern Europe. The anti-immigrant movement at the time was based primarily on economic grounds—cheap labor taking jobs from American citizens—and the arguments were similar to those heard today against Hispanic and Asian immigrants.

An illustrated article in the August 1923 issue of *Arts and Decoration* magazine gives some measure of Knox's impact on the perception of immigrants. Titled "An Artist Who Changed Immigration Laws, the Story of the Woman Painter Whose Ellis Island Studies Moulded Legislation" and reprinted by the *Portsmouth Herald* with the headline "Local Woman Artist Whose Work Changed Immigration Laws," these articles quite clearly chronicle the artist's powerful message to regular citizens as well as politicians. These paintings were also exhibited in Washington, D.C., at the Corcoran Gallery (the first one-woman show ever held there) and in many cities across the country, including Portsmouth. It was no wonder she was one of the town's "Famous Sons and Daughters."

She became so interested in immigrants that she followed those who settled in New York City to the Lower East Side, painting scenes of their lives there, and she paid some to sit for her in her studio. Some of these scenes are in an impressionistic style, also similar to Robert Henri and the Ashcan School. She is quoted as saying, "I think art should concern itself with the conditions of the time in which the artist lives, especially when color is so rampant as in the lives of these foreigners." Knox would have seen Henri's work in New York (and possibly met him there), but she did certainly know him in Ogunquit, Maine, where he spent the summer of 1915 with George Bellows.

At her York Harbor studio, Knox painted Anne Harrison Newman, a ten-year-old niece of her close friend Josephine Hamill. Newman remembers Knox was a frequent visitor to Hamill's home in Naples, Florida, and recalls hearing Knox, Hamill and the other adults talk admiringly of Robert Henri.

Knox would describe beach parties composed of a small group, including Henri, sitting around a fire in Ogunquit, watching the flames reflected in the water. Knox seems to have mastered the impressionistic manner very well, as her Lower East Side paintings are very skillfully done, but she soon returned to the more formal academic style that was her livelihood.

Knox was a good businesswoman who sought out wealthy clients. Her studio on Shore Road in York Harbor, Maine, was the Marshall House, a now long-gone summer hotel noted for its affluent guests. The Marshall House displayed her paintings, and in return, Knox and her mother received their meals at the hotel. In this way, she could not only show off her work but also mingle with the guests and pick up possible commissions. According to Mrs. Newman, all of her work was for sale, and those paintings not sold during the summer were open to bids at the end of the season.

Before the Marshall House was demolished in the early 1970s, the contents were sold at auction. There were still many of Knox's paintings there, and they realized rather low prices. Today, the property of the old Marshall House is occupied by the Stage Neck Inn and the separate residential Stage Neck Colony. Sadly, the management at both establishments has no knowledge of Susan Ricker Knox or her work.

The prolific Knox did not confine her work to York Harbor, Ogunquit and New York. An article in the *Kansas City Star* of January 15, 1915, reports, "An exhibit of portraits and paintings by Susan Ricker Knox will open today at the Findlay Gallery," and goes on to state, "Her pictures have been seen at the Chicago Institute, the Albright Gallery in Buffalo, the New England Academy of Fine Arts, the Paint and Clay Club of New Haven and the

Connecticut Academy of Fine Arts. Miss Knox is now living in Kansas City and will establish a studio there."

While there, she was commissioned by the Kansas City Board of Trade to do a portrait of E.D. Bigelow, the board's former secretary. The completed portrait received much praise. Her work was well received at exhibits in St. Louis, Missouri, in 1925 and San Diego, California, in 1929. She also exhibited at the Poland Spring Art Gallery in Poland Spring, Maine; in Rochester, New York; in Chicago; in Dallas; in Phoenix; at the National Arts Club in New York; and in Gloucester, Massachusetts. Throughout her career, she had more than thirty-one one-woman shows, an incredible number for this busy artist who belonged to the membership of several art associations and clubs.

As the 1920s drew to a close, Knox abandoned her New York winter studio and established herself in Mesa, Arizona. Earlier in the decade, she had been painting portraits in Naples, Florida, and had met Josephine Hamill, an independent-minded widow of her own age who was a painter of miniatures and a member of the artistic circle there. Hamill painted for her own pleasure only and did not sell her work. The two became fast friends and traveled together to paint in the Southwest and Mexico until Hamill's death in 1947.

Knox loved color and was drawn to the Southwest by the vivid hues and bright sunlight. In an autobiographical statement published in the *Literary Digest*, September 24, 1932, she gives another reason for wanting to paint in this desert region: "An experience of painting at Ellis Island, immediately after the war, gave me such a love for character stuff that I always longed to see what the even more primitive mind was like, hence the lure of the Indian of the Southwest. I have painted the Hopi, the Apache, the Yaqui, the Maricopa and the Pima races." (Of course, the term "primitive mind" is not politically correct today, but Knox was simply reflecting the racial classifications and terminology of her own time.)

Her paintings, however, of both the immigrants and the Native Americans and Mexicans are always empathic and harmonious. Here again, she may have been inspired by Henri, who painted the American Indians of New Mexico in 1916, 1917 and 1922. At any rate, she liked the peoples of the Southwest and their colorful environment, infused with sunshine.

Industry and Indolence, displayed at the Portsmouth Athenaeum exhibit, captures the brilliant Arizona sunshine, the colorful dress and relaxed friendliness of two Pima women. One is working on a basket, the other half asleep in the sun while a baby on her lap peers mischievously at

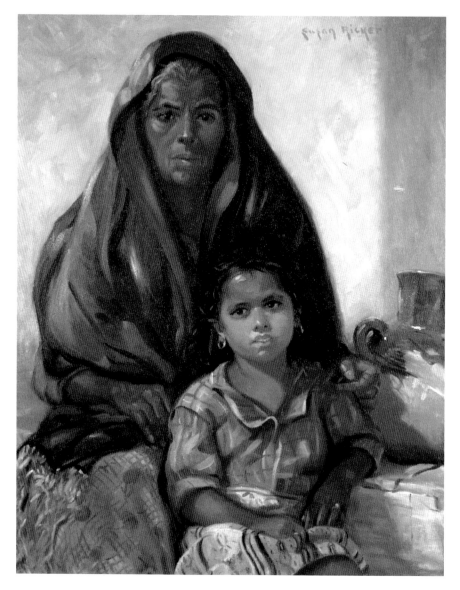

Abuela y Nieta, oil on canvas. *Courtesy the Estate of Jane D. Kaufmann.*

the viewer. Knox occasionally painted landscapes, and there is a fine, strong painting of orange cliffs, their bulk weighty in sun and shadow. Not located are two paintings of young chiefs in their bright and colorful native garb.

In 1935, Knox traveled to Mexico and painted at Oaxaca and Taxco. An article in the magazine *Mexican Life* in June 1943 states she painted "the scenes and types of the Guerrero countryside with singular warmth and understanding." Her Mexican work was exhibited at the Mexican Pavilion at the 1940 New York World's Fair, and in 1943, the Mexican government exhibited her paintings at the Palacio de Bellas Artes in Mexico City.

Although the author of the *Mexican Life* article, Guillermo Rivas, describes this exhibit in glowing terms as "a thoroughly memorable experience…Mature and definitive…honest, direct and free of esoteric artifice," the museum today has no record of it, nor does it hold any paintings of Susan Ricker Knox.

Rivas continued in his praise of Knox, writing about her naturalness, her portrayal of human character with understanding, tenderness and realism, which, he says, "is devoid of cruelty." Her brushwork is bold, and "she has a genuine feeling for color…she handles her paint not only to capture the precise tone and shade of color but to build with it a veritable texture."

This description of her painting technique holds true to her pieces throughout her career. It can be seen in her portraits, in the Ellis Island paintings and in her work in the Southwest. Knox painted not only in oils but also in watercolor, and she also did still lifes, block prints and landscapes.

In 1933, she was interviewed by the *Boston Sunday Post* and gave her ideas about portraiture: "A real portrait is not a slavish copy of external characteristics, but an interpretation of a personality. It is the spirit that is the reality." The painter "has a tremendous responsibility to carry to a finish the making of an honest and conscientious interpretation of the character of another human being." From the point that the sitter loses his self-consciousness and assumes a characteristic position, "the painter's concern is with the picture…on the canvas the subject is now reduced to the simplest terms of masses of light, shade and color."

Finally, the portrait emerges in the third dimension, and the final attention is given to the eyes so that the subject's individual expression and personality come through in a lifelike portrait.

Knox did not anticipate that her career and work would be forgotten, for she went on to say that while a portrait should be a representation of the likeness and personality of the sitter it should have a "pictorial quality which should make it interesting to some future possessor, who might not have known the subject. It should decorate the space in which it is to hang, and add color, harmony and vitality to its surrounding." Apparently, she saw her work being appreciated forever, like that of the old masters.

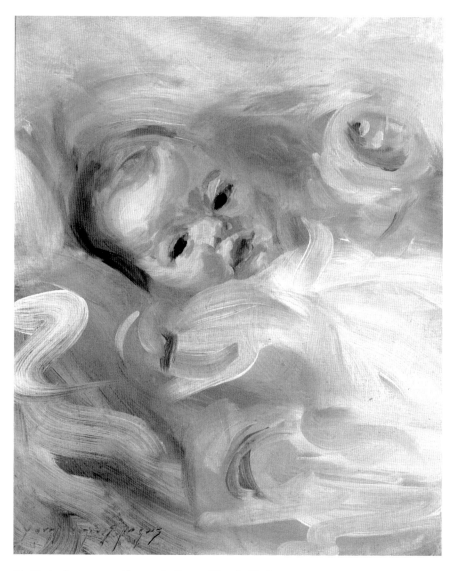

Untitled, oil on canvas. *Courtesy the Estate of Jane D. Kaufmann.*

In this same interview, she describes her procedure when painting a child. Because "usually a child seems to typify perpetual motion, the presence of a third person is necessary. The painter, I feel, should be relieved of all outside effort, and the child entertained so that he may enjoy the sittings and be rested rather than be tired by them."

Clearly, this approach was not always successful. In the Portsmouth Athenaeum exhibit, there is a charcoal portrait, done in 1904, of two little Massachusetts brothers wearing their best clothes. They are beautifully placed, but perhaps there was no one to entertain them, because the expressions on their faces reveal they did not want to pose.

Other child portraits in the exhibit are more successful. Two little York Harbor sisters were favorite subjects, and Knox paid them twenty-five cents an hour to sit for her. The handling of this portrait and that of *Little Miss Coxie Green* are reminiscent of Henri's child portraits for their color and feeling.

Knox's parents had only two children, Susie and a younger son, John. The son married and moved away, and after the death of their father in 1900, the responsibility for the care of their widowed mother fell to Susan.

At one point, Susan Ricker Knox spent a great deal of time in the winter in Naples, Florida, at Josephine Hamill's home, where she was treated like a member of the family. Mrs. Newman remembers Knox being very pleasant and shy but a good conversationalist who would tell entertaining stories about her days as an art student. In spite of her shyness, she had a good sense of humor and she was very much a lady.

After her mother died in 1932, Knox was more or less lost, but Josephine Hamill was a great comfort.

Always, she was a very kind person. When Anne Newman was growing up and beginning to use makeup, Knox showed her how to put it on and helped her to choose the right color to complement her hair. Those who knew her observed there were no men in the artist's life. She blushed too easily when teased and would have been too nervous and shy to date. She seemed to be an "innocent with a virginal side," and while she caught the spirit of her sitters in their portraits, she may never have really understood them.

In an interview in *All Arts* magazine in 1927, Knox spoke of her feeling about the future of American art and the effect of foreign painters on it: "We shall have no great American art until we learn to patronize our own people. Many foreign painters come here and commercialize their art, and they are literally grabbed by people as soon as they come and these foreign artists in many cases with very little background, paint pictures for which Americans pay big sums, while there are painters in our own country who could give them such superior work and yet they do not appreciate it or realize it."

Knox was a truly American painter and a truly modern woman. She chose to make her way in a field in which women were only beginning

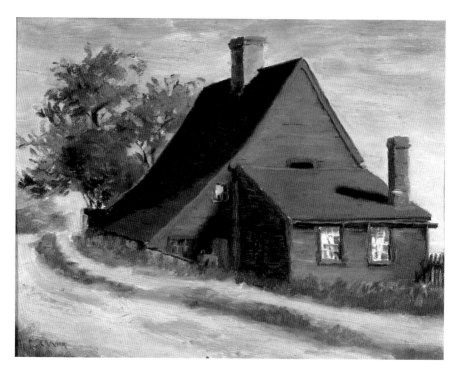

Jackson House, Portsmouth, oil on artist board. *Courtesy Collection of Dr. Richard Candee and Robert S. Chase.*

to be accepted, and she was successful at it. While some of her work was influenced by other artists, she does not fit into any particular school. In her paintings, she was herself. Like many fine female artists, her work has been more or less forgotten, though it does not deserve to be.

Rose Rizza Fiandaca, 1893–1980: North End Matriarch

BY LAURA POPE

On July 22, 1975, eighty-two-year-old Rose Fiandaca took center stage as the recipient of the Portsmouth Service Mother of the Year Award, bestowed at the award banquet given in her honor at Portsmouth's landmark restaurant and conference center, Yoken's.

As a charter member of Service Mothers for thirty-three years, the energetic Italian woman had earned long-standing esteem not only for her involvement in civic group projects but also for her nurturing of an entire community.

Friends, family and city officials gathered for the occasion, made more significant when Mayor Eileen Foley presented a gift to Rose, purchased thoughtfully by the mayor's office and Senator Tom McIntyre. Her niece sang several songs, and the club president and others staged a retrospective of Rose's life, as a book with pictures and stories about Rose circulated among the assembly.

The day overwhelmed the beloved matriarch with memories. In her long, productive life, this woman, orphaned at a young age and adopted by relatives, had immigrated to America, married a Sicilian immigrant in Boston and moved to a thriving Italian neighborhood in Portsmouth, a small city along a river in southern New Hampshire. Here, she would become a central figure in a district whose very existence divided an entire city.

She would become representative of all that was extraordinary about her district and, more astonishing, watch with dismay and quiet dignity at its demise. Ultimately, she was proved right about the value of her community to the city, the region and the state.

Rose's children—Sadie, Angelina and Joseph—remember their childhood home in Portsmouth at 35 Russell Street with clarity and fondness. As first-generation Americans born to Sicilian immigrants, the siblings recall their hardworking parents, a vibrant neighborhood filled with friends and a time when growing up without much money did not automatically eliminate a carefree and happy existence.

These memories include ones of their indomitable mother, Rose, who raised her offspring as well as their cousins and became a loving fixture, emissary and matriarch for the entire neighborhood.

Rose Fiandaca stayed at home to raise children and keep house like the other mothers in the district. She was one of the women in the quarter who assisted others as a midwife because the doctor was not always available. "There was a high rate of infant mortality in the neighborhood, as there was everywhere else at the time," said Mary Ciotti, a neighbor on Russell Street whose family members were early arrivals in the snug parcel of land near the river. "It seemed as if everyone had a brother or sister who died from pneumonia or other childhood disease."

Losing children at a young age was something Rose experienced herself. After giving birth to her first daughter, Sadie, in 1913, Rose's next child, a daughter named Angelina, died at six months. Her next daughter, also named Angelina, died at eighteen months. Finally, her fourth daughter, again named Angelina, called Ann, lived. She gave birth two more times, to son Michael and, in 1921, to her youngest, Joseph.

As a practiced midwife, Rose was often consulted on medical issues. "My mother was the one who got the sick in the neighborhood to the doctor, the pharmacy and everything else," recalled Sadie. "She always helped."

Joe remembered many of his mother's efforts during World War II: "She helped at the USO. And she was the woman in that neighborhood helping out with little and big things. She would read letters, written in Italian, for her neighbors and write letters back."

Sadie added: "Once when an Italian ship was in port, the shipyard people called her and asked her to help out. She had several sailors to our house for dinner. Of course, they thought our Italian was not that good."

Rose DeStefano LaMarca, another North End neighbor, wrote down the good deeds of Rose Fiandaca for the public record. "Rose Fiandaca was the stabilizing force of our street. She was the only one with a telephone. No matter what situation confronted us, we would go to her for help. Call the doctor, explain a letter, help us bake a birthday cake or sew a dress for a special occasion."

Rose came to Portsmouth indirectly. Like many immigrants who found a home in the river port, Rose was born into an agricultural family situated on a farm in the town of Caltanissetta, southwest of Enna, in central Sicily. She was born in 1893, the second child and daughter of Carmalla and Marco Rizza, arriving six years after her sister, Providence.

"When Rose was ten months old, her mother was taken seriously ill," wrote a family member in a scrapbook of old photos. "Her father went to town to get some medicine for his wife. When he arrived, he found people in the streets protesting against high taxes. There were soldiers all over town ordering people to go home or they would be shot. Rose's father wanted to get the medicine for his wife, so he continued to walk toward the drug store. He was the first one to be shot and killed by the soldiers."

Conflicts such as the one that killed Marco Rizza were not uncommon in Italy during the last years of the nineteenth century. Local mounted police called *carabinieri*, revolutionaries and residents clashed when Socialists fanned the flames of discontent over poor harvests and unemployment.

An increasingly hostile social environment, coupled with subsistence farming and brutal poverty, made the long trek to other countries seem less of a risk and more a means of survival, especially for southern Italians who suffered more than most because of their harsh landscape.

Daughter Ann recalled, "Carmalla died a month later, leaving Providence and Rose orphans. Marco's brother, Carmello Rizza, and his wife, Angelina Ciangelo, were a childless couple who wanted the girls and took them into their home and raised them as their own. They had a little farm, as most people did, which was quite a way from the house. Rose went to school through the fourth grade and still helped on the farm and would ride a horse bareback to and from the farm."

Providence, who had married Salvatore Gangi in 1904 and moved to America, sent for Rose and her adoptive parents a few years later. They settled close by in Boston. In this bustling city of immigrants, Rose went to school and worked at a candy factory.

In 1911, at age eighteen, Rose met her future husband, Gaetano "Tony" Fiandaca of Portsmouth, when he was in Boston visiting a friend. Tony worked at a Portsmouth shoe factory for a few years and, later, took a job at the Portsmouth Naval Shipyard as a chipper and caulker, a physically demanding job that involved chiseling steel with an air hammer. They were married on January 1, 1911, at the Sacred Heart of Jesus Church in Boston. For their honeymoon, they came to Portsmouth, where they bought a house on Russell Street.

Rose moved to 35 Russell Street when she married Tony Fiandaca in 1911. *Courtesy Pamela Fiandaca Given.*

Their street was only one thread through the densely occupied North End neighborhood, composed of closely situated homes on several streets within a ten-acre tract from Congress Street on the south to roughly the North Cemetery on Maplewood Avenue, over to the Sheraton and then to Portsmouth Parade on Market and Deer Streets.

It was best described as Portsmouth's Italian North End, and it existed for almost seventy years, from 1905 until the late 1960s. Its largest intact population flourished for forty years, from the onset of steady settlement in 1905 until after World War II, when children born into the neighborhood settled elsewhere.

Many of the homes there were stalwart, well-made structures erected by well-to-do seventeenth- and eighteenth-century sea captains and merchants, the very same class of people who also built homes and took up residence in the South End of Portsmouth in an area called Puddle Dock.

During the period when Rose and her adoptive parents had settled in the Boston area, southern Italians were making the trip across the Atlantic in droves. From 1901 to 1913, more than 90 percent of immigrating southern Italians made the trip while northern Italian immigrants preferred the less strenuous destination to other European countries.

These new arrivals to America tended to settle in various cities with existing Italian neighborhoods. Italians from specific towns congregated in neighborhoods where their comrades were already established. It was not uncommon for residents of a small Sicilian village to slowly resettle a town in America.

Portsmouth City Directories, kept by the city every year since the 1880s, chronicle the influx of Italians into the North End, where Rose and Tony bought their house on their move to Portsmouth. In directories for 1901 and 1903, Russell Street was occupied by families with Irish and English surnames—Driscoll, Leary, Donovan, Junkins and Connors.

In 1910, a clear trend was obvious. Russell, Deer and Market Streets were bustling with Italian residents with mellifluous names: Zamarchi, Gallo, Vicini, Perrini, Letterio, Moratto and Ferrella—just to name a few.

By 1920, the Russell Street community, as well as Wall Street, Russell Alley and other nearby streets, was predominantly Italian. In fact, Russell Street sounded like any Italian neighborhood in any city, alive with the names of the Pastoro, Addosio, Flavia, Destage, Di Poalino, Fiandaca and Rizzo families, who often split a house into a duplex to accommodate more than one family.

Tony, like Rose, first set foot in Boston upon arriving in America. Some of his siblings followed afterward. Joe recalled his father's emigration story: "When my father was thirteen or fourteen years old, he ran away from

home, near the same small town where my mother grew up, and with money borrowed from a priest, made the trip overseas. After the third grade, it was nothing but farming from morning to night. When he got to Boston, he was taken in by a family who found him a job as a laborer…the Italian community took in boarders all the time."

Joe's sister Ann recalled her father spending time living with the Mangano family in Portsmouth before acquiring his Russell Street home. The Mangano and Stella families lived in a grand three-story brick house, built in 1913 by Epifanio Stella, a stone mason from Messina. The spacious building, still standing, housed three generations of the Stella and Mangano families plus a thriving barbershop at 206 Market Street that even included a pool table.

Joseph Fiandaca, the baby of the family, described the house at 35 Russell Street as a tan-colored duplex, with seven rooms and a bathroom on each side plus a house garden out back.

Behind the gardens on the Fiandaca side of Russell Street, freight and passenger trains rambled by, departing from and arriving at the passenger and freight train station at the far end of Vaughan Street. During the Great Depression, the rambling poor found a meal from kind residents who lived near the tracks on Russell Street.

The eldest Fiandaca child, Sadie, provided more detail about her father's duplex: "My Uncle Rosario lived in New York City, and during World War I, the influenza epidemic took his wife's life. They then moved into our house with us, and when our grandmother Rizza, who had been living on the other side, moved, Uncle Rosario and my cousins, Anthony, Angelina and Rosario Jr. (who was called Ra), moved in. We had several tenants share our house. For a while, our closest neighbors, the Caninos, lived next door in our house, until they moved across the street."

Joe summoned up the memories of other occasions, too, such as taking the train to Woburn to visit his Aunt Providence and her family, including her thirteen children. He also savors the warm nights on Russell Street listening to music: "My cousin Ra playing the accordion, Paulie Notto playing guitar and singing, the cop, John Sullivan, who stopped by to listen on his rounds and to enforce the nine o'clock curfew." Sadie added: "That man always had a pocket full of candy to pass out to all the kids."

The Italian social clubs in Portsmouth organized to form food co-ops and social events for the growing Italian population in town. According to Joe, the membership of these clubs was loosely based on regional heritage.

"The Romans had their club, the Sicilians theirs. It's not that we didn't get along; in fact, we had Calabrese, Romans and Sicilians right on Russell

Street," he remembers. The Italian Republican Club, which owned the Italian Co-op Market, boasted a bocce court for its members on Green Street, recollected Joe, who said the other clubs were located on lower State Street near the Memorial Bridge, at the corner of Russell Street and on the corner of Market and Hanover Streets.

Sadie clearly remembered the good parties the Italian social clubs hosted on Saturday nights: "Ra and I used to sneak down there to Market Street to listen to the music and watch the people dance."

Rose, like other local housewives, had a number of stores in which to shop, just footsteps away. In addition to Mario's Meat Market, Cavaretta's on Russell Street offered general foods and boasted a common oven where women could bring their bread to bake or select from the store's inventory of loaves. Another enterprise, Macrelli's Bakery, offered Cavaretta's some competition, while Addorio's served as the close-at-hand convenience store. At that time, much of Portsmouth's populace had their ice and milk products delivered, a service the North Enders also patronized.

If customers did not have enough choice at Mario's Meat Market or the other neighborhood stores, outside vendors, selling live chickens or grapes for winemaking, also frequented the closely knit neighborhood.

One Saturday a month, the Zufanti Imported Foods vendor came up from Boston in his truck, taking and dropping off orders of macaroni, cheese, olives and other specialty foods. Other neighbors in the Italian district could always take the nearby passenger train to Boston, but often, salesmen and services from outside the vicinity made house calls. The Italians made sure their culinary needs were met, either at their door, a short walk away or at the end of a train ride.

It's not hard to imagine the comfortable proximity of homes nestled in the North End or the boisterous dinner conversations and enticing cook stove odors spilling out into the streets.

Indeed, the surviving children of Rose and Tony Fiandaca still savor the good meals served in their home. "At Christmas, there was us, plus our two uncles, Rosario and John, plus our cousins," said Sadie. "We had a huge dinner and the night before everyone stayed up late playing cards." In summer, sumptuous picnics were packed for outings, homemade wine was a neighborhood staple and music always added to the pleasure of eating.

Ann and her friend Connie Canino noted that gardening put a great deal of food on the tables of the area's blue-collar families. "I can still taste those peaches from our peach trees," exclaimed Canino. "They were the best. Grapes and tomatoes could be found in every garden. The best grapes in

the neighborhood were grown by Tom Minnichello, and cuttings were taken from his arbor and planted in front of the Walsh house at Strawbery Banke just before the neighborhood was demolished."

Ann still cherishes the lush gardens, the taste of the good meals and the memories of good times: "I keep looking for the lilac tree that was in our yard at Russell Street. Joe took a piece of it to plant at his house."

In the Portsmouth Athenaeum publication *Families from Afar: Settling in Portsmouth 1900–1930*, historian Ronan Donohoe chronicles more neighborhood businesses, revealing an Italian North End that was self-reliant. In addition to recruiting much of the labor force into the area that would settle the North End, Joseph Sacco ran a grocery and provisions store and the Banca Italiana at 10 and 14 Deer Street. Together with Frank Lizzio, the two had much to do with the creation of the North End as a community of Italians.

The enterprising spirit was contagious. Pasquale Caruso kept a grocery store at 210 Market Street, Rafael Paola ran a saloon at 214–220 Market Street and Charlie Moratto operated a restaurant at 244 Market Street across from the coal company, now the site of the industrial-grade salt pile.

Employment was a key concern in this work-centric community.

During high school, Joe spent his summers working at Abe Shapiro's shoe shop, trimming shoe bottoms on a machine. Tony arranged the job for his son through Abe, as he had worked at Shapiro's for a time and continued to repair Abe's shoe machines.

Many Italian men worked at Shapiro's or Continental's shoe shop. Construction jobs were another source of employment for the first Italian settlers in Portsmouth, though the Portsmouth Naval Shipyard would become a major employer.

Rose's youngest, Joe, worked at the shipyard for thirty-two years as a ship fitter. In 1941, he entered the yard's shops, left for war in 1943 and returned three years later after serving in the navy in the Pacific on large amphibious landing craft, or an LST. His brother, Michael entered the army in 1942, fought in Europe and took part in the D-Day invasions at Normandy. During World War II, young men in the North End were scarce as military service beckoned to most.

Holding more than one job was not uncommon. For four years, Joe Fiandaca also worked as a butcher at the famous Mario's Meat Market on Market Street, one of the many specialty stores catering to the needs of the Italian neighborhood. Joe recalled: "My neighbor Michael Canino worked in the other Italian market at the corner of Market and Green Streets, the Italian Co-op Market, owned by one of the Italian clubs in town and

operated by a Mr. Bizzochi. Together, Michael, who had married Louise Ciotti, and I bought Mario's. He taught me the meat business, but the supermarkets killed us."

Sadie, firstborn to Rose and Tony, met her future husband, Benjamin Bukata, at a cousin's wedding at the Immaculate Conception Church in 1940: "When I was growing up, a group of northern Italians in the neighborhood were not Catholics. Father Belluscio, from Immaculate Conception, converted many of them. He was a popular figure in the neighborhood."

Father John J. Belluscio served as associate pastor at Immaculate Conception Church from 1930 to 1938 and then served several New Hampshire parishes before eventually became a monsignor. "The father started a choir and a school for kids to learn Italian. I learned to read and write Italian there," said Sadie. Rose DeStefano LaMarca also recalls Father Belluscio as the founder of the Saint Theresa Club for young people, the very place Sadie learned Italian, and the Santa Lucia Society for the women.

"The Prescott sisters used to come by and pick up my mother to bring her to the Santa Lucia Club at the Farragut school, where she and other Italians learned to read and write in English," said Connie Canino. Rose, of course, had already been the neighborhood's translator and letter writer. Still, the Santa Lucia Club was a great way to socialize with women in and outside the North End.

Ann, Joe, their siblings and neighborhood friends attended the Farragut School. Connie Canino and her lifelong friend, Mary Ciotti, recall their parents were anxious for their American-born children to learn and speak English. Sadie Fiandaca remembered Italian mostly being spoken in the house but being able to speak English by the first grade.

Rose herself had few career opportunities, though her daughters and sons, raised with examples of a strong work ethic all around them, would seek the education and opportunity afforded first-generation Americans.

Friendships made on Russell Street and elsewhere in the neighborhood proved to be lifelong associations.

Ann graduated from Portsmouth High with the class of 1935. While in high school, she learned the hairdressing trade, like her next-door cousin Angelina, and worked at the Favorite Beauty Shop. Later, she took a job doing office work at the shipyard, as did her neighbor and friend Mary Canino, where she worked for fourteen years until she was married.

"We had quite a crowd of friends. There was Edie DeStefano from 26 Russell Street, Connie Canino who lived across the street at number 40,

myself and Connie Cochario. We were the 'Just We Four Club,'" Ann recounted. The foursome would visit the Olympia Fruit Store and Ice Cream Parlor after the movies at the Olympia Theater.

She and her friends, like many teens living in the North End, frequented the swimming hole at the Littlefield Wharf in summer months. Connie Canino met her future husband, Fred Gallagher, at the waterside hangout.

"Sometimes," said Connie Canino, "we felt self-conscious outside our neighborhood. We stuck to our own."

Though Rose and other residents of the North End always considered their homes the focal point of their families and, taken together, a sanctuary of cultural identity, many in Portsmouth were dismayed at the architectural decay in the district. Many felt the neighborhood an eyesore though an important location for business.

At the time, town fathers anticipated bulldozing the neighborhood to build a grand hotel at the site, a $2 million mini–Prudential Center.

In response to the threat of "permanent renewal," Portsmouth Preservation Inc. was formed in April 1968. This organization hoped to educate the federal government and local townsfolk and officials about the treasures that would be lost if the Vaughan Street Urban Renewal Project went forward. Specifically, it hoped to buy the more architecturally valuable homes within the North End and resell them for restoration purposes. After a review of the targeted neighborhood, sixty homes were earmarked for Portsmouth Preservation restoration, and a change in zoning from industrial-municipal to residential-commercial was deemed necessary.

In March 1969, members of the preservation group visited senior officials of Housing and Urban Development (HUD) in Washington, D.C., but in the end, the Portsmouth City Council voted seven-to-one to go forward with renewal rather than restoration.

When the shovels and bulldozers of urban renewal swept through the North End neighborhood in late 1969 and well into the 1970s (the last of the large renewal projects in the entire nation), only a small group of structures, seventeen in all, was saved and moved across the street to an area called "the Hill." Among the group of center chimney Colonials, Georgian, Federal, Greek Revival, Italianate and Victorian structures within the North End, several were cited as important, including the 1756 Hart Rice House, noted for its large, hipped Georgian roof; the 1795 Jeremiah Hart House, featuring a Georgian center chimney plan; the 1766 Richard Shortridge House, with its rare broken scroll pediment; and the frail, but still architecturally stunning, Phoebe Hart House, dated to 1800, now the site of the Blue Mermaid restaurant.

"Just We Four Club." *Back row, left to right*: Connie Canino, Connie Cochario. *Bottom row, left to right*: Ann Fiandaca, Edie DeStefano. *Courtesy Pamela Fiandaca Given.*

Architectural historian and consultant to Strawbery Banke museum Richard M. Candee, at the behest of Portsmouth Preservation, assessed the more than three hundred structures in the North End prior to HUD demolition. While many were architecturally worthy, only "a baker's dozen of structures were purchased by Portsmouth Preservation from HUD and were saved," said Candee. He continued: "Of course, HUD didn't want to know there were valuable places being knocked down. At the time, the federal tax system was against preservation. The knock-it-down and build new viewpoint was prevalent then. What is now Strawbery Banke was saved from HUD demolition a few years earlier, in part because the rents in town were so low at the time, making any new construction unwise from a financial viewpoint. The plan for the North End was to level the district to make way for a hotel. We at Portsmouth Preservation predicted it would be years before a hotel was built, and we were right."

In the 1963 City Directory, Rose and her son Michael Fiandaca were listed as residents at 35 Russell Street, the Caninos still lived across the street and Tito Zoffoli still ran his grocery at number 45. By 1965, six families had vacated Russell Street. In 1971, Russell, Wall and Vaughan Streets had been obliterated.

"Before the neighborhood went down, my mother relocated to Feaster Apartments on Court Street," explained Sadie. Joe will never forget the grim feelings among those who grew up in the Italian North End when demolition started: "I was in Kittery when Connie Canino called us to say our house was next. I grabbed a few pieces of the house for sentimental reasons, the day it came down. The Canino house was the last one knocked down on our street."

"Wherever she went, my mother was an enthusiastic person," said Sadie. "At Feaster, she continued as always, asking residents if they needed anything at the post office or store. She was always helpful and thoughtful."

A memorial bench bearing the names of sixty-six Italian families who settled the North End was dedicated on June 8, 1998, at the corner of Market and Deer Streets in front of the Sheraton Hotel. The occasion sparked a large gathering, a reunion of Italians who had lived in the district.

For many, the official recognition of their distinct neighborhood was long overdue, though still sweet. Nonetheless, as the years have proven and as Rose and her neighbors wished, restoration rather than urban renewal made much more sense. As one of the last HUD projects of this scope in America, the Vaughan Street Renewal Project made a neighborhood extinct that, if saved and restored, would have proved far more effective in reviving local and state economies.

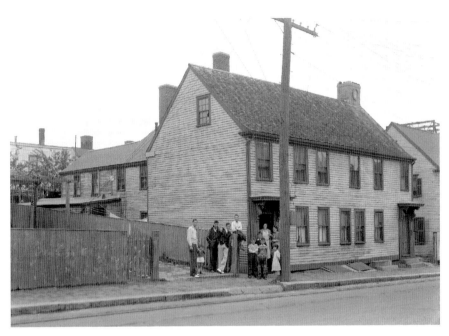

Above: Locals in front of the first period 1705 John Hones House at 33–35 Deer Street, one of hundreds leveled by the Vaughn Street Renewal Project. *Library of Congress photo.*

Left: Rose Rizza Fiandaca. *Courtesy Joseph Fiandaca.*

More importantly, the collective experiences and memories of those gathered confirmed that the ethnically distinct North End, no matter the state of the structures, was filled with families and individuals with a history all their own.

"Warm evenings were filled with happy sounds," wrote Rose DeStefano LaMarca. "We would build a bonfire, and the sound of guitar strumming, accordion music and singing voices filled the warm evening air. At the close of the day, the sound of my mother's voice called out, 'Come here now, it's getting late.'"

Mary Carey Dondero, 1894–1960:
An End to Politics as Usual

BY DENISE J. WHEELER

By 1944, hundreds of Portsmouth residents had bid their families goodbye and joined the country's fight in World War II. German subs trolled the waters off the coastline. Gasoline, paper, some foods and other everyday products were rationed. Occasional blackout drills seemed to serve as omens of dark times ahead.

While the city faced the challenges of being at war, it was also confronting municipal conflicts. The population had increased by 40 percent during the previous twenty-five years, and the city's leaders faced unprecedented traffic, water and housing issues. As the mayoral election loomed in November, citizens knew how important their vote would be and, respecting that responsibility, voted into office a former beauty queen who had not made it through eighth grade.

From inauspicious beginnings, Mary Ellen Carey Dondero set a deliberate course to shape her community with a decidedly nurturing political bent. She became one of the first women elected mayor in New England, was a state representative in the legislature for eleven terms and served as a member of the city council until the year she died.

Commemorating her efforts in 1960, the *Portsmouth Herald* said, "No other person in modern times did more to shape the pattern of politics in Portsmouth than Mrs. Mary C. Dondero. There was none who commanded a more loyal following in public life; none whose personal imprint upon the political affairs of the community was more deeply etched."

Perhaps her dedicated compassion for the people of Portsmouth stemmed from the circumstances of her youth. Mary Carey was the second of eight

children in a poor family that lived in the South End. Her parents, Dennis Carey and Nora Leary, were natives of Portsmouth whose parents had come from Ireland. They were plain-mannered, plain-spoken people. Her father worked on the docks at the foot of Daniel Street, along the Piscataqua River, where the swelling current is among the fastest in the nation. Dennis and Nora had two children, a son and daughter. Dennis died four months after Mary was born in what the local newspaper called an accident on the waterfront; while shoveling coal from a barge, Dennis fell into the storage pit.

In those days, the waterfront was rough and ramshackle, and Mary's descendants were told by a local historian that it is more likely Dennis was involved in a fight and pushed to his death.

Nora went on to have six children with her second husband, John Wade, an immigrant from Nova Scotia. They lived in a large, simple house on Court Street where Nora took in laundry to help support the family. Mary left grade school to pitch in by delivering the wash. She would pile heaps of clothing onto a horse-drawn wagon and then maneuver it down the narrow road where landmarks of the city's historic significance, such as the Stavers' Tavern where George Washington stayed in 1789, were flanked by the run-down tenements of immigrant families.

At the end of the nineteenth century, when Mary was a young girl, Portsmouth's population mirrored that of many small New England cities, an almost equal mix of native born and recent immigrants. In 1908, the first historic house restoration opened to the public on Court Street, not far from Mary's house. It was the home of author Thomas Bailey Aldrich, whose novels drew heavily from his life in mid-nineteenth-century Portsmouth. The building's grandeur among the adjacent sagging ones was symbolic of conflicting housing issues that would gnaw at Mary throughout her years in public office.

On July 4, 1913, at the age of nineteen, Mary wed Charles Anthony Dondero. He was a kind Italian man who worked at the store his father had established in the heart of downtown Portsmouth. Dondero's Fruit and Ice Cream Store was nestled between a café and a shoe store on bustling Congress Street. The couple moved into an apartment above the store and had four children, all girls: Anna Geraldine, Jacqueline, Helen Eileen (who went by her middle name) and Charlotte Constance (who went by the name Carlotta).

Mary balanced her life by tending to her home and raising a family while becoming a vibrant part of her community. When World War I began, she, like many other women, adapted her lifestyle to meet the country's needs. Although there were bans against women working in heavy industry, she

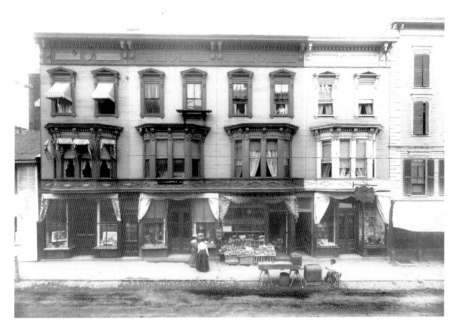

Dondero's fruit stand on Congress Street where Mary lived with her husband, Charles, and four daughters. *Patch Collection, Strawbery Banke museum, Portsmouth, New Hampshire.*

showed her patriotism by volunteering with the Red Cross and assisting in Liberty Loan drives. In 1918, when the war ended, the city celebrated with its first "Miss Portsmouth" competition, and Mary, the mother of three, was crowned the winner.

"When you saw my mother, the first thing you would notice about her was that she was a tall, elegant brunette," said her third daughter, Eileen Foley. "She wore dresses or suits with gloves and had long brown hair."

The U.S. stock market crashed in 1929, yet the fruit store managed to provide for the family throughout the Great Depression. Reflecting on life as a child in that neighborhood, Eileen said the family never had much money but led a happy life together: "We were a below-middle-class family. The street was lined with wooden buildings with little windows in the front of each. When urban renewal came, they removed that whole section of Congress Street.

"Congress Street was the main street of the city, but it was a fun place to grow up. Our backyard was made up of restaurants and stores and a blacksmith's shop. My sisters and I would go down and watch the man shoe horses or we'd play in a field where an auto dealer parked old cars until my mom would holler to us that it was time for supper."

The civic work Mary started in World War I was followed by her first foray into politics in 1928. She campaigned for Al Smith, the first Roman Catholic to run for president. Although he lost, the experience gave Mary the inspiration and the votes that led to her first political role, a seat in the state legislature in 1934.

"She was the 'Sweetheart of the House,'" Eileen remembered. "She was one of only two women in the House when she started. People there gave her flowers every morning."

Having successfully added to the female perspective in the legislature, Mary set her sights on local politics. In 1940, she made a successful bid as the first woman to serve on the Portsmouth City Council.

A dedicated Democrat, Mary held several party offices throughout her life, including delegate to the Democratic National Convention, head of the Democratic City Committee and vice-chairman of the Democratic State Committee. Her work was so influential that the *Portsmouth Herald* described Mary as "the embodiment of the party in Portsmouth. Having revived it at a time of stagnation, she made it over into her own image and thus created an organization that had to be reckoned with in every political plan."

When Mary began her journey to the peak of Portsmouth's political landscape, the country was poised to enter a global war on two fronts—Japan and Germany.

On December 7, 1941, Japanese planes attacked the American military base in Pearl Harbor, Hawaii, leaving the U.S. Pacific fleet crippled. Portsmouth joined the rest of the nation as it mobilized for war. In the hours after the bombing, harbor shipping and private flying were stopped, the Portsmouth Naval Shipyard and Harbor Defenses were manned and recruiting officers found themselves swamped with applicants.

The war raged for almost four years, becoming the most costly and murderous international conflict in history. Yet even as Mary empathized with families sending their loved ones off to fight, she was dealing with inner conflicts. Her husband Charles, who had given up the store and then left his subsequent job at the Internal Revenue Service, was suffering from psychological issues. He had been unemployed for years when he was admitted to a hospital where his mental and physical health steadily deteriorated. On February 14, 1944, Mary found herself saying goodbye to him; Charles died from what his children were simply told was a "lingering illness."

In the weeks following Charles's death, Mary moved into a house on Middle Road, and her two youngest daughters, Eileen and Carlotta, left Portsmouth to join the military. The two oldest Donderos were married, but

the youngest wanted to emulate women throughout the country who were working in military hospitals and offices, driving Jeeps, ordering supplies and nursing the wounded.

Mary was proud of her daughters not only because they were patriotic but also because they all had something she did not—a college education.

"Because my mother never graduated from eighth grade, she always said, 'My girls are going to go to college,' and we all did," said Eileen. "It wasn't easy because we did not have a lot of money."

Living alone for the first time in her life, Mary was anything but lonely. Aside from her political work, she held a clerical position at the navy yard, as the shipyard was called back then. She manually worked a machine that was the forerunner of today's copiers, but her employment, like her political life, was about being a part of a community.

"She made lunches for everyone in her office," Eileen remembered. "She kept a jar of mayonnaise in one drawer and mustard in the other. The janitor was always heating water for her in his closet."

Mary was also running a grassroots mayoral campaign at that time, writing letters and handing out sample ballots.

"The house was never quiet after the kids were gone because she was busy all the time," Eileen said. "She loved the telephone, and when she ran for office, she'd call people and ask, 'How do you think I'm doing?' She wanted to be reassured. That was the kind of person she was."

When the United States joined World War II, bans against women working in the defense industry and other forms of heavy labor were lifted. By 1945, one out of every four women in the United States worked for wages.

"During the war, women did everything, especially at the navy yard," said Eileen, pointing out that they related easily to the "Rosie the Riveter" image of a woman flexing her muscles on the job. "If a woman wasn't the painter, she was the painter's helper. It was very, very different there for everyone. Buses went back and forth twenty-four hours a day." Approximately twenty-two thousand people worked there.

In an article on the subject, the *Portsmouth Herald* noted: "Portsmouth was indeed a crowded town in those days as people rented rooms, attics and even cellars to the flood of workers who came together for the effort that would see the construction of 85 submarines in the years between 1939 and 1945. A familiar sign in a house window around the city read something to the effect: 'Quiet, Please. War Worker Sleeping.' And they were. Three shifts a day was the order as the yard, in spite of blackout regulations, was a fairyland of lights night after night."

The daughters of Mayor Mary Carey Dondero, *left to right*: Carlotta Bailey, Jacqueline Mitchener, Geraldine Sylvia and Eileen Foley (who would also become mayor of Portsmouth). Eileen is holding a framed photo of Dondero's portrait. *Courtesy Mary Carey Foley.*

Even Mary's half sister Anne Sadler worked there as a pipefitter's helper, but as women filed into the navy yard, Mary left to make history as Portsmouth's first female mayor at the age of fifty. News accounts reported her winning in a recount by seven votes.

"She was delighted," Eileen said. "She even received a couple of marriage proposals by mail after winning. She thought they were hilarious."

However, Eileen added, the serious issues at hand were foremost on her mother's mind. Mary joined families regularly at the train station as they said goodbye to their recruits. "She'd see off every group of soldiers, no matter what time they left, and she would give them writing paper, cigarettes and little American flags," Eileen recalled.

"She was at the USO hall every night, greeting troops and planning events for them such as spaghetti suppers. She was marching with the Service Mothers' Club every day and also helped run war bond drives."

On May 7, 1945, the German High Command surrendered to the Allied armies, and Mary issued her V-E Day Proclamation: "A long, bitter chapter in the world struggle has been brought to a close but total victory is not ours yet. This is a day not of merrymaking and rejoicing but of thanksgiving and prayer. Thanksgiving that the horrible battle in Europe is ended, and prayer for an early victory in the cruel battle ahead."

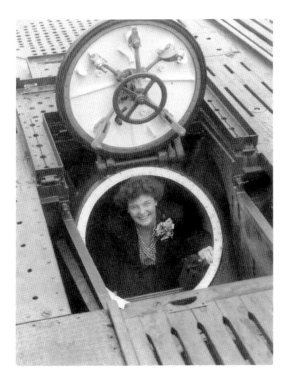

Mayor Dondero emerges from a submarine at Portsmouth Naval Shipyard. *Courtesy Mary Carey Foley.*

The war with Japan lagged into summer. Then, on August 14, 1945, the atom bomb ended it. With the destruction of Hiroshima and Nagasaki, Japan surrendered and peace returned to the world.

The following day, the *Herald* reported on the city's celebration, in which Mary and her daughters took part: "Thousands of Portsmouth residents thronged the streets of the downtown district last night in a spontaneous celebration of news of the end of the war. It was but a matter of seconds after the first news was flashed to the country when autos began to zip down Congress Street with horns blaring, their occupants blowing whistles and shouting the good news."

The only planned event of the night was a band concert on the square, followed by a parade in which Mary and her daughters were driven in a Jeep through the business district. They waved at the revelers who were cheering and embracing on the streets.

Despite the euphoria over the end of World War II, female workers were not content with the changes just around the corner, Eileen recalled. Their positions within skilled labor were to be short-lived because general opinion about women's role in society had not shifted.

Mayor Dondero oversaw the installation of the city's first parking meter. *Courtesy Mary Carey Foley.*

As it had done after World War I, the government conducted propaganda campaigns glamorizing motherhood and urging women to become homemakers again. This would ensure that male soldiers got their jobs back when they returned.

"But women missed their paychecks," Eileen noted.

Many of the servicemen and civilian workers who had come to the New Hampshire seacoast because of the war stayed. As mayor during the following two years after the war had ended, Mary addressed the city's growth by opening schools, a public pool, a health center and an auditorium at the Connie Bean Center. She also oversaw the installation of the city's first parking meter.

Although she was known for her compassion, Mary was also feisty and aggressive. "There were always fireworks coming out of the mayor's office when she was there," Eileen remembered. This determination helped Mary reform a political system noted more for its ballot box stuffing than for its honesty. And more change was to come.

In the early 1940s, a new form of governing had been adopted by several large cities, including Cambridge, Massachusetts. The system, which had advocates in Portsmouth, called for hiring a full-time city manager who would run municipal government under guidelines set by the city council, in effect, excluding the sole governance of the mayor.

The local newspaper was a proponent of the city manager form of government, taking its first stand on this issue in July 1942 and keeping the idea alive through various editorials and articles. Although Mary was an outspoken foe of the plan, when leaders from Cambridge were invited to speak about it at a Rotary meeting in December 1945, she welcomed them. The proponents of this reform waged a strong campaign prior to elections in 1947, but the manager referendum apparently went down in defeat—until Mayor Dondero stepped in.

She pointed out it appeared the will of the voters had been tampered with in Ward Two. Though she was against the referendum, she exposed suspicions about Republican counters she had seen tabulating the votes. Due to this, a public hearing was held, and she requested a recount. It showed the plan had been adopted.

Despite her objections about this form of government, Mary ran for a seat on the new city council and was the top vote getter. The win started a pattern that was to repeat itself every two years until her death, except for a term when she served as acting postmaster in the early 1950s. The highest office for which she made a bid was the state senate in 1948, which she lost by one vote in a recount.

Her effect on local politics was so sound that after her death, Republicans in the state legislature redesignated the wards in the city, a practice called gerrymandering, putting through a bill that was, according to historian and former *Portsmouth Herald* editor Ray Brighton, "aimed at crimping the power of the late Mary C. Dondero." In his chronicle of Portsmouth's history, *They Came to Fish*, Brighton described Mary as a leader who "struck terror in all good Republican hearts. She had all the ruthlessness of any of the tough male politicians around town, and her femininity gave them fits because they never quite knew how to strike back."

The end of the strong-mayor form of government found Mary looking for a full-time job. A friend with a big empty house in Stratham suggested she use the building to start a nursing home. Mary, who loved the elderly, took him up on the offer. While maintaining her seats on the city council and in the legislature, she ran a convalescent home with the help of her two half sisters, Marguerite Murphy and Anne Sadler. Anne also ran for

a seat on the legislature and won. In 1953, the two sisters served in the House together.

At the age of ninety-six, Anne looked back at her sister's career in the legislature and said, "She was a truthful and great politician. She did her homework and talked with voters. If a subject was brought up and the speaker said 'We Democrats believe…' she would ask the speaker not to speak for her, then she would say her piece.

"She didn't show prejudice. If someone lied, she called [him] on it. She took interest in protecting the underdog."

When the time came for her to co-sponsor a bill to allow women on juries, she turned to her college-educated daughters for assistance. Eileen said her mother was self-conscious because she had so little schooling and often asked her girls to help with speech writing and grammar.

"She had us go over every word of that bill. She was one of the two sponsors, and we had to be sure everything was grammatically correct."

The bill passed.

Politics and the convalescent home filled Mary's life, but the two did not always work in harmony. Mary's biggest political controversy with the local media came when the *Portsmouth Herald* claimed she spent so much time in Stratham that she was violating the city councilors' residency requirement. After a series of articles and editorials, the paper brought suit against her. Mary won her suit but purchased a new nursing home at 401 Islington Street in Portsmouth to avoid further allegations.

It was a three-story building with a cozy atmosphere. Mary's daughter Eileen visited daily with three of Mary's nine grandchildren—Jay, Barry and Mary Carey Foley, the granddaughter named for her.

The children would visit with the seniors and do errands, bringing them newspapers or running down to the Beverage Barn to fetch sodas for them.

"My Grammy Dondero spoiled us. She'd pile us into her yellow Chevy BelAir and take us out for ice cream," remembered Mary Foley. "She knew all the stores in Boston and took us down there for a shopping spree for my First Communion. She bought me three dresses for that day."

Acts such as this were typical of Mary Dondero. The little money she made she spent on others.

"My mother lived day by day," Eileen said. "If she had a check, she'd blow it on three or four nosegays for elderly people who were turning ninety or one hundred, then she'd be scrounging by the end of the month."

The legacy Eileen and Mary Carey Foley recall the matriarch passing along to them was this: "Do something nice for someone every day."

Eileen Foley, daughter of Portsmouth's first female mayor, Mary Carey Dondero, became the city's second female mayor, serving several years: 1968–71, 1984–1985 and 1988–1997. Portrait by Phillip Benson, dated 1998. Photo by Richard Hopley. *City of Portsmouth, New Hampshire.*

Mary's years on the city council after her stint as mayor marked a turning point in Portsmouth's history. The topography was changing dramatically. Several areas, including Prescott Park and the area along the waterfront south of the Memorial Bridge, were marked for "urban renewal," which meant sub-standard homes there would be destroyed. Privately financed housing projects, such as Elwyn Park, began. The city's first shopping center, Islington Street Plaza, was built. With the start of the Korean Conflict in 1950, new and bigger jet bombers were needed, and the U.S. Strategic Air Command determined the New Hampshire seacoast would be a fitting home for them. Construction on the Pease Air Force Base began in 1954, and the field, complete with massive jet hangars and runways more than two miles long, was dedicated in September 1957. About seven thousand men were assigned to the base, and Portsmouth faced another growth spurt. New schools were built, and businesses boomed.

At the same time the city council was overseeing this, it was also hearing plans to renovate the Puddle Duck area across from Prescott Park, near where Mary had grown up. The area, which was punctuated with scrap heaps and dilapidated homes, was slated to become Strawbery Banke museum, where historically and architecturally significant buildings would be preserved. Although she suffered from a stroke as project plans began, Mary rose from her sickbed to fight it. Though the neighborhood was shabby, residents wanted their homes there protected.

The controversy was sparked in 1957 when librarian Dorothy M. Vaughan spoke at a Portsmouth Rotary Club meeting. She said each time a house was torn down for the sake of "urban renewal" or a piece of

furniture was sold out of town, it unraveled the fabric of the city's rich and colorful heritage. The Rotary took the cause to heart and started a committee to look into the matter of acquiring land and combining federal and state urban renewal with historic restoration. Families would be relocated, and more than forty buildings not suitable for restoration would be demolished.

The project was fought at every stage. Objection voiced at public hearings ranged from pragmatic debates over the amount of property to be taken from the tax assessment rolls to the heartfelt issues of removing residents of the proposed area from their homes. Mary embraced the latter cause.

"After my mother's stroke, we had to feed her, she was relearning how to walk, she was disoriented and she lost use of her left hand. Still, she rose from her deathbed to fight Strawbery Banke because she was a real people person, and people in the neighborhood asked her to help them fight," Eileen recalled. "No matter what the problem, whether it was over a pothole, kids getting in a fight or losing a home, my mother would represent the people who needed her."

But Strawbery Banke was an issue Mary would not see to fruition.

The November before her death, she won reelection, leading the city slate by more than four hundred votes, the highest number ever accrued by a candidate. She died at age sixty-six on March 24, 1960, of a massive stroke. The next year, a new elementary school on Van Buren Avenue was dedicated in her name.

Mary Dondero's allure stemmed from a personality characterized as tough, direct and strong-willed, yet her actions as a leader showed a nurturing compassion that helped a city become a community. While Mary was mayor, it was said, no person went to a funeral alone; she went along to hold a hand. She created a Recreation Commission and acquired recreational facilities to build camaraderie. Strong, sensitive and sensible, she was a poised woman whose political pursuits were fueled by genuine patriotism and deep, personal values about education, civic pride and responsibility. She suffered personal loss, won political campaigns by the narrowest and largest of margins and, despite her successes, did not fail to remember where she came from and who she represented.

In the days before her death, she asked her family to place an ad in the local paper. It read, "My heartfelt thanks go to you, the people of Portsmouth, for the faith and trust you have placed in me and the many honors you have bestowed upon me…I hope I have lived up to my code:

Mary Carey Dondero portrait
by Philip's Studio. Photo
by Richard Hopley. *City of
Portsmouth, New Hampshire.*

'And when the One Great Scorer comes
And writes against your name
He writes not that you won or lost
But how you played the game.'

God bless all my friends and God bless my enemies, too."

The *Portsmouth Herald* called Mary's death "the end of an era" and said, "Over the past twenty years, Mrs. Dondero prevailed as the greatest single dominant force in local politics."

While she instituted much positive change and reinvigorated the Democratic Party, Portsmouth was, at the time of Mary's death, very much like it was at the time of her birth: a city seeking a way to balance its past, present and future. This conflict, however, created a colorful and diverse community, and it is a tribute to Mary that, from unremarkable origins, she led it so remarkably.

Select Bibliographies

BRIDGET CUTT DANIEL GRAFFORT

Cutt, Eleanor. Will. 1684. New Hampshire Provincial Papers. Vol. 1. Concord, NH, 1623–86.

Cutt, John. Will. 1680. New Hampshire Provincial Papers. Vol. 1. Concord, NH, 1623–86.

Cutt, Richard, to Thomas Daniel. Deed. 1671. Portsmouth Athenaeum Collection.

Cutt, Richard. Will. 1675. New Hampshire Provincial Papers. Vol. 1. Concord, NH, 1623–86.

Daniel, Thomas. Will. 1683. New Hampshire Provincial Papers. Vol. 1. Concord, NH, 1623–86.

Graffort, Bridget, to the Town of Portsmouth. Deed. 1700. Vol. 1. Portsmouth Town Records 1645–1713.

Graffort, Bridget. Will. 1701. New Hampshire Provincial Papers. Vol. 1. Concord, NH, 1623–86.

Graffort, Thomas, and Bridget Graffort to Robert Hopley. Deed. 1685. Portsmouth Athenaeum Collection.

New Hampshire Court Records. State Papers. Vol. 40. Concord, NH.

New Hampshire Probate Records. *Inventory of the Estate of Bridget Graffort, 1703*. Vol. 4. Concord, NH.

Shurtleff, Nathaniel B. *Records of the Colony of Massachusetts Bay in New England*. Vol. 4–5. Court records re: Richard Cutt. Concord, NH.

Vaughn, William, to Governor Bradstreet. 1690. Massachusetts Archives, 36.87.

ALLICE SHANNON HIGHT

Brighton, Ray. *They Came to Fish*. Portsmouth, NH: Peter Randall, 1994.

Conroy, David W. *In Public Houses*. Chapel Hill: University of North Carolina Press, 1995.

Garvin, Donna-Belle, and James L. Garvin. *On the Road North of Boston: New Hampshire Taverns and Turnpikes, 1700–1900*. Concord: New Hampshire Historical Society, 1988.

Marsh, Thomas Shepard. "'A Sparrow Alone on a Housetop': Portsmouth, New Hampshire." *Widows in Debt-Related Civil Suits, 1715–1770*. Master's thesis, University of New Hampshire, 1992.

Scott, Kenneth. "Colonial Innkeepers of New Hampshire." *Historical New Hampshire* 19, no. 1 (Spring 1964): 3–50.

SARAH HAVEN FOSTER

Caldwell-Hopper, Kathi. "An Artistic View of Portsmouth." *Network Publications*, October 1992.

Foster, Sarah. *Portsmouth Guidebook: A Survey of the City and Neighborhood.* Portsmouth, NH: Joseph H. Foster, 1884.

Hall, Alvin. "Window to the Past." *New Hampshire Profiles*, November 1988.

Ingmire, Bruce. "Sarah Haven Foster Has Roots in Port City Bookshop." *Portsmouth Press*, July 1991.

Local newspaper microfilms: 1853, 1877, 1876, 1883, 1885, 1892, 1900.

Payson, Aurin, and Albert Laighton. *Poets of Portsmouth.* Boston: Walker, Wise and Company; Portsmouth, NH: Joseph H. Foster, 1865.

Peabody, Andrew. *The Life of John Foster.* Portsmouth, NH: Joseph H. Foster, 1853.

Portsmouth Journal of Literature and Politics, August 1900.

Wendell Collection of Manuscripts. Portsmouth Athenaeum: Portsmouth, NH.

ELLEN AND HELEN GERRISH

Cromwell, Giles (Virginia Historical Society Museum registrar). Telephone interview with Kate Ford Laird, September 23, 1997.

Frisbee, O.L. "Captain Edwin Augustus Gerrish." *Island and Harbor Echo* [Kittery Point, ME] 4, no. 1 (January 1897): 9–11.

Hackett, William H. "A Reminiscence of the Alabama." *Granite Monthly* 6, no. 12 (September 1883): 382–83.

Hugill, Stan, ed. *Shanties from the Seven Seas: Shipboard Work-Songs and Songs Used as Work-Songs from the Great Days of Sail.* London: Routledge & Kegan Paul, 1961.

Leckie, Robert. *None Died in Vain: The Saga of the American Civil War.* New York: HarperCollins, 1990.

Portsmouth Cemetery Records. Portsmouth, NH. Vol. 1.

Portsmouth Directory. Portsmouth, NH. 1850–1941.

Portsmouth Herald. Portsmouth, NH. (In particular June 25, 1864, and May 18, 1940.)

Portsmouth Journal of Literature and Politics. Portsmouth, NH. (In particular December 26, 1891.)

Portsmouth Male Census Listings, 1850–1900. Portsmouth, NH.

Semmes, Raphael. *The Cruise of the "Alabama" and the "Sumter": From the Private Journals and Other Papers of Commander R. Semmes, C.S.N., and Other Officers.* 2 vols. New York: Carleton, 1864.

Skaggs, Jimmy. *The Great Guano Rush: Entrepreneurs and American Overseas Expansion.* New York: St. Martin's Press, 1994.

South Church Records. Portsmouth, NH. 1922.

Vaughan, Dorothy. Interview with Kate Ford Laird, September 24, 1997.

MARY BAKER AND ALTA ROBERTS

Asay, Charles. Deed. *Registry of Deeds*, Exeter, NH. 1898, 1899, 1911, 1922, 1927, 1929, 1935.

Baker, Mary. Deed. *Registry of Deeds*, Exeter, NH. 1903, 1933, 1934, 1936, 1959.

———. Last Will and Testament and Estate Schedules. Office of Probate, Exeter, NH. 1909.

Bond, Mattie. Deed. *Registry of Deeds*, Exeter, NH. 1893, 1895, 1899, 1902, 1907, 1908, 1912, 1913.

Brewster, Charles W. *Rambles About Portsmouth*. First series. Somersworth: New Hampshire Publishing Company, 1971.

Brighton, Ray. *They Came to Fish*. 2 vols. Portsmouth, NH: Portsmouth 350, Inc., 1973.

Bullard, Harry. Deed. *Registry of Deeds*, Exeter, NH. 1910, 1911, 1912, 1913.

Cemetery Indexes for Sagamore, Harmony Grove and Proprietors Cemeteries. Special Collections Room, Portsmouth Public Library, Portsmouth, NH.

City of Portsmouth Police Department Record Books of Arrests. Four vols. 1892–95, 1897–98, 1901–05, 1906–13. Manuscript 33. Portsmouth Athenaeum, Portsmouth, NH.

Dale, Charles. Deed. *Registry of Deeds*, Exeter, NH. 1935, 1936, 1937, 1938, 1939, 1940, 1941, 1954.

Dunn, William. Last Will and Testament and Estate Schedules. Office of Probate, Exeter, NH. 1917.

Guest Book from the 1982 Puddle Dock Reunion in Portsmouth, NH. Special Collections Room, Portsmouth Public Library, Portsmouth, NH.

McLaughlin, Robert E. *Water Street*. New York: Carlton Press, Inc., 1986.

Minutes of the Portsmouth City Board of Police Commission Meetings, 1895–1901, 1912, 1913. Portsmouth Athenaeum, Portsmouth, NH.

Portsmouth Annual City Reports. Boston: Greenough, 1871–1930.

Portsmouth City Book Directory. 1856–57, 1860–61. Portsmouth, NH: CW Brewster, 1856, 1860.

Portsmouth Directory Containing the City Record, the Names and Citizens and a Business Directory. Boston: WA Greenough Jr., 1864.

Portsmouth Directory of the Inhabitants, Institutions, Manufacturing Establishments, Business, Business Firms, Societies, Map, State Census, Etc., for the City of Portsmouth. Boston: WA Greenough, 1901, 1910, 1914, 1920.

Portsmouth Herald. January 1–December 31, 1911; 1912; 1913; June 26, 1922. Microfilm. Portsmouth Public Library, Portsmouth, NH.

Portsmouth Naval Shipyard Log Book of Daily Activities. 3 vols. 1900–13. Portsmouth Naval Shipyard Museum, Kittery, ME.

Prescott, Josie F. Deed. *Registry of Deeds*, Exeter, NH. 1934, 1935, 1937, 1938, 1939, 1940, 1941, 1954.

Roberts Alta. Deed. *Registry of Deeds*, Exeter, NH. 1897, 1902, 1908, 1909, 1911, 1919, 1937.

———. Last Will and Testament and Estate Schedules. Office of Probate, Exeter, NH. 1938.

Stewart, Charles H. Deed. *Registry of Deeds*, Exeter, NH. 1905, 1906, 1908, 1909, 1910, 1911, 1912, 1918.

———. Last Will and Testament and Estate Schedules. Office of Probate, Exeter, NH. 1937.

Susan Ricker Knox

Child, Deborah M., and Jane D. Kaufmann. "Susan Ricker Knox (1874–1959)." *American Art Review* (August 1998).

———. "Susan Ricker Knox: Portsmouth and Beyond." Exhibition catalog. Portsmouth Athenaeum, Portsmouth, NH, 1998.

Estate of Susan Ricker Knox, Deceased June 11, 1959. Merrimac County [NH] Probate Records 51358. Concord, NH.

Fairbrother, Trevor. *John Singer Sargent.* New York: Harry N. Abrams, Inc., 1994.

Gloucester Society of Artists. Exhibition catalogues. Third Exhibition, August 18–September 9, 1928; Thirty-fifth Exhibition, June 19–July 30, 1935.

Juley, Peter A., and Son. Collection of photographic negatives. National Museum of American Art. Smithsonian Institution, Washington, D.C.

Kansas City Star, January 15, 1915.

Knox, Susan Ricker. Birth Record. Office of the City Clerk. City of Portsmouth, NH, January 26, 1874.

————. Registration Record. Information and Student Records. Drexel University, September 1896–February 1899.

Lawton, Alice. "Susan Ricker Knox, Painter of Portraits All the Way Across the Continent, Discusses Portraiture." *Boston Sunday Post,* September 10, 1933.

Leeds, Valerie Ann. *My People, the Portraits of Robert Henri.* Orlando, FL: Orlando Museum of Art, 1994.

Lowes, Frederick. "Susan Ricker Knox." *AN Arts* 3, no. 1 (January–February 1927).

"Migration." *Encyclopedia Britannica* 15. Chicago: William Benton Publisher, 1960.

"Miss Susan Ricker Knox." *Literary Digest,* September 24, 1932. Typed partial transcript. Scrapbook, Portsmouth Public Library. Portsmouth, NH.

National Arts Club, New York City.

Newman, Anne Harrison. Telephone interview with Jane D. Kaufmann, August 10, 1998.

New York City Telephone Directory Manhattan and the Bronx. October 11, 1911: 281.

North Shore Art Association of Gloucester. Catalogue of the Fourteenth Exhibition, July 5–September 12, 1936. Courtesy of Dr. Richard Candee.

Pageant of Portsmouth. Tercentenary souvenir booklet. Portsmouth, NH, 1923.

Smithsonian Institution, Washington, D.C.

St. Louis Post Dispatch. "Paintings by Susan Knox Have St. Louis Showing." October 11, 1925.

ROSE RIZZA FIANDACA

Bohne, Ann Fiandaca. "Rose Fiandaca." Fiandaca family scrapbook, 1974.

———. Telephone interview with Laura Pope, November 10, 1997; July 29, 1998.

Bukata, Sadie Fiandaca. Telephone interview with Laura Pope, October 24, 1997; July 29, 1998.

Candee, Richard M. (architectural historian who participated in review of North End for Portsmouth Preservation). *Building Portsmouth: The Neighborhood and Architecture of New Hampshire's Oldest City.* Portsmouth, NH: Portsmouth Advocates Inc., 1992.

———. Telephone interview with Laura Pope, July 31, 1998.

Donohoe, Ronan. *Families from Afar: Settling Portsmouth, 1910–1930.* Portsmouth Athenaeum exhibit catalogue. New Hampshire Humanities Council, 1997.

Fiandaca, Joseph. Interview with Laura Pope, October 26, 1997; telephone interview, July 29, 1998.

LaMarca, Rose DeStefano. "Childhood Memories Still Alive, North End Fostered Family Intimacy." *Portsmouth Herald*, June 7, 1998.

———. "Russell Street Remembered." *Portsmouth Herald*, July 28, 1985.

Pope, Laura. "Portsmouth's Italian North End an American Dream." *Portsmouth Herald*, October 8, 1989.

———. "Summer Nights: Memories of an Italian Neighborhood." *Strawbery Banke Newsletter*, October 1981.

Portsmouth City Directory, 1901, 1903, 1905, 1910, 1912, 1914, 1920, 1963, 1965, 1971.

Portsmouth Herald. "North End Community Fights for Old Homes." November 22, 1968.

Robinson, J. Dennis. *Russell Street Reunion*. Video documentary. Portsmouth, NH: Ideaworks, 1986.

Thoresen, A. Robert. "Before and After Urban Renewal." *Portsmouth Herald*, December 13, 1992.

Vento, Jenn. "Just Like a Family Reunion, Old North End Families Honored." *Portsmouth Herald*, June 8, 1998.

Williams, Sydney. "Portsmouth's Response to Urban Renewal." *Worcester Sunday Telegram*, September 14, 1969.

MARY CAREY DONDERO

Atwood, Albert W. "Northeast of Boston." *National Geographic Magazine*, September 1945.

Brighton, Raymond A. *They Came to Fish*. Portsmouth NH: Portsmouth 350, Inc., 1973.

Durel, John W. "Historic Portsmouth: The Role of the Past in the Formation of a Community's Identity." *Historical New Hampshire* 41 (1986).

Foley, Helen Eileen Dondero. Interview with Denise J. Wheeler, July 1997; telephone follow-up, February 1998.

Foley, Mary Carey. Interview with Denise J. Wheeler, July 1997.

Garraty, John A., ed. *Women and the Work Force.* New York: Houghton Mifflin Company, 1994.

Heffernan, Nancy Coffey, and Ann Page Stecker. *New Hampshire: Crosscurrents in Its Development.* Hanover, NH: University Press of New England, 1996.

Lewiston Daily Sun. "Woman Sworn in as Portsmouth Mayor." January 2, 1945.

New Hampshire Notables. Concord, NH: Concord Press, 1955.

Portsmouth Herald. "500 Attend Service for Ex-Mayor Dondero." March 28, 1960.

———. "Mrs. Dondero, Leader in Civic Affairs, Dies." March 25, 1960.

———. "Mrs. Dondero—The End of an Era." March 28, 1960.

Sadler, Anne. Interview with Denise J. Wheeler, July 1997.

Your City Government, 1945, 1946, 1947. Portsmouth, NH: Strawberry Bank Print Shop, 1997

About the Authors

Kathleen A. Shea is the director of the New Hampshire Farm Museum in Milton. She worked for many years at Strawbery Banke museum and has a longtime interest in Portsmouth's history. She pursued her master's degree in American and New England studies at the University of Southern Maine. She lives with her husband in Portsmouth, where they serve as caretakers for the Jackson House, the oldest house in New Hampshire.

The late **Elizabeth Putnam Nowers** received her bachelor of arts degree in history from the University of New Hampshire. She was the librarian for the Town of Nottingham, New Hampshire, for nine years. She worked for six years at Strawbery Banke museum as an interpreter, role player and program assistant in the textiles and wardrobe department.

Maryellen Burke is the executive director of the Portsmouth Historical Society, which operates the John Paul Jones House and Discover Portsmouth. Discover Portsmouth is the city's visitor center, which promotes historic houses, theaters and museums. She is the former president of the Portsmouth Athenaeum. She received a doctorate in literature from the University of Florida. She is married to history writer J. Dennis Robinson. They live in Portsmouth, not far from the downtown she loves.

The great-great-great-granddaughter of a Durham shipbuilder, freelance writer **Kate Ford Laird** has a bachelor of arts in history from Harvard and a one-hundred-ton master's license from the U.S. Coast Guard. She has sailed for a year before the mast on a square rigger and raced across the Southern Ocean below fifty degrees South. Since writing this chapter, she

has visited Cape Horn many times by sailboat and spent the last five years chartering in Antarctica and South Georgia with her husband, Hamish, and daughters Helen and Anna. They're now bound for Alaska.

Kimberly Crisp is a local realtor who is completing her master's degree at the University of New Hampshire. Inspired by family stories of her great-great-aunt Alta Roberts, Portsmouth's red-light district was the subject of her 1996 honors thesis at the University of New Hampshire. She lives in Newfields, New Hampshire, with her husband, John, and their sons, Aidan and Samuel.

The late **Jane D. Kaufmann** received her bachelor of science from Northwestern University in Evanston, Illinois, and her masters of arts in American studies from Boston University. She lectured and published on a wide range of topics, including calico printing processes, New England mill housing, American colonial portraiture and early American domestic architecture. The author was co-curator, with Deborah M. Child, of the exhibit "Susan Ricker Knox, Portsmouth and Beyond," which was displayed June 9 through September 8, 1998, at the Portsmouth Athenaeum.

Laura Pope first heard about Portsmouth's Italian North End when working as an archaeologist at Strawbery Banke museum in the early 1980s. Since that time, she has written several articles about this extinct immigrant oasis for regional newspapers and magazines. She works as a freelance journalist and editor, specializing in Portsmouth history and arts and entertainment.

Denise Wheeler's interest in Mary Dondero stems from her ties to the *Portsmouth Herald* and the statehouse. She was the *Herald*'s arts editor for five years. When she first embarked on this project in the early 1990s, her father, Robert L. Wheeler, was the House majority leader for New Hampshire. Also at that time, Eileen Foley was mayor of Portsmouth. Foley chaired the city council for eight terms seated under a portrait of her mother.

Visit us at
www.historypress.net
...
This title is also available as an e-book